Something

One Day,

Happens:

A selection by
JENNIFER HIGGIE from the
Arts Council Collection

D1473419

Paintings of People

One Day, Something Happens: Paintings of People

A selection by
JENNIFER HIGGIE from the
Arts Council Collection

 HAYWARD PUBLISHING

 ARTS COUNCIL COLLECTION AT SOUTHBANK CENTRE

Contents

Foreword

For nearly 70 years, the Arts Council Collection has supported artists based in the UK by purchasing their work. Now numbering nearly 8,000 artworks, and including many of the best-known names in twentieth- and twenty-first-century British art, it is the most widely circulated of all national collections, reaching beyond museums and galleries into schools, hospitals, universities and libraries. The Collection has been built through the support of the many distinguished artists, curators and writers who have been invited to advise on the purchase of works and it is arguably in this very open and democratic approach to acquisition that the Collection's greatest strength lies.

We had known Jennifer Higgie for a number of years, mainly through her role as Co-Editor of *frieze* magazine, but this association was strengthened when she joined our Acquisitions Committee in 2011. During her two-year tenure, her thoughtful and intelligent approach to the very serious business of acquiring art for the nation was invaluable, so we were delighted when she accepted our invitation to curate an exhibition of paintings. Her training as a painter, combined with the two years spent as part of our Acquisitions Committee, has undoubtedly helped her to shape the show that she has curated. Collections can be strange beasts to understand, but from the very outset she was clear that the exhibition should encompass figurative painting and be drawn entirely from our holdings.

This exhibition does not set out to provide a definitive guide to British figurative painting, nor is it a chronological survey, but instead reflects a very personal view of a period of radical change in art. If there is a departure point, it lies in the group of works by the Camden Town Group – Walter Sickert, Malcolm Drummond and Walter Bayes – some of our earliest acquisitions. We can see in many of the paintings the art historical influences felt by the artists, but the exhibition primarily captures stories and snapshots of lives past and present. By choosing work by the well known and not so well known, it is as if this exhibition has drilled down to the very heart of the Arts Council Collection to tell a wider story of the twists and turns of British figurative painting over the past century.

All exhibitions require a great deal of hard work behind the scenes and, from the Arts Council Collection team, I should like to give special thanks to my colleague, Curator Ann Jones. She has worked alongside Jennifer for many months now and her in-depth knowledge of the Collection has been vital to the development of this exhibition. My thanks also go to colleagues Catherine Antoni, Steven Burridge, Ben Fergusson, Catherine Gaffney, Ann Jones and Natalie Rudd for their informative texts on the works. Thanks are also due to the Collection technical team, Andy Craig, Ben Hudson and Joshua Dowson, as well as to Hayward Gallery's registrars, technical teams and Eimear Martin, Assistant Curator at the Hayward Gallery, for their invaluable assistance.

We should also like to express our gratitude to those artists and curators who have provided texts or information about works in the exhibition, in particular Glenn Brown, Milena Dragicevic, David Noonan, Paula Rego, Rose Wylie, Lynette Yiadom-Boakye, Mel Gooding and Harriet Loffler.

Our Hayward Publishing team, led so ably by Ben Fergusson, has produced yet another beautiful publication for us and our special thanks go to them. Between them they have produced a book to delight us, which will have a life way beyond the exhibition tour.

At the point of writing this foreword we have secured five venues for the exhibition and are grateful to the following institutions and staff for their hard work and enthusiastic support for the exhibition: Sarah Brown and Nigel Walsh, Leeds Art Gallery; Deborah Dean and Tristam Aver, Nottingham Castle; Aoife Ruane, Highlanes Gallery, Drogheda; Stephen Whittle, The Atkinson, Southport; and Sanna Moore, Towner, Eastbourne. We look forward to working with them in the months ahead.

Lastly, our warmest thanks go to Jennifer Higgie for her insightful essay produced here in this publication and her hard work in selecting such a beautiful exhibition. I would like to pay tribute to the intelligence she has brought to the whole process and for being an absolute pleasure to work with.

Jill Constantine, Head: Arts Council Collection

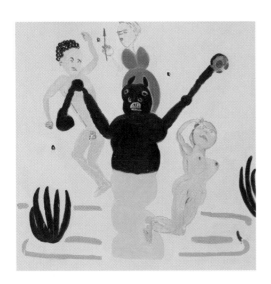

GEORGIA HAYES
*SAVED BY DROWNING
(SICILIAN FOUNTAIN 2)*
2013

One Day, Something Happens
Jennifer Higgie

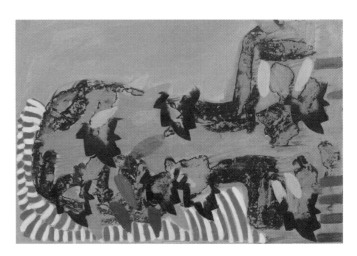

PHOEBE UNWIN
Sleeper
2012

'On a series of apparently tiresome, flat sittings seeming to lead nowhere – one day, something happens, the touches seem to "take", the deaf canvas listens, your words flow and you have done something.' Walter Sickert

The real history of art is not neat; it twists and turns back on itself; it changes its mind and is very good at keeping secrets. It includes far more women than are usually mentioned; it is idiosyncratic, eccentric and often enigmatic. When I first studied art history at high school, and then again at art school, the progression of ideas in paint and other media was presented to us as something linear and rational; as if one idea led to another with the inevitably of a bus timetable. I soon learned, however, that while the broad brushstrokes, if you will, of art history do of course represent actual movements and developments, the day-to-day life of art-making is not so easily categorised. Inspiration and imagination are impervious to timetables and art historians are picky: they often discuss the artists who fit their thesis, rather than reflecting the messy, and often unquantifiable, reality of who is making what when.

Artists are not mathematicians or accountants; they do not care for checks or balances, or for necessarily proving anyone right or wrong. Art is the result of too many factors to be any single thing: it can be both a reflection of its time and perversely an argument with it; it can converse charmingly with its peers or fight tooth and nail for a certain position; it can be easy going, as clear as a bell, or wilfully confusing. It can aim to communicate to as many people as possible or relish its enigma; it can be a form of propaganda or dissent. It can be 'big-P' political or embrace the idea that the personal is political. Its intentions can be international or local; it can be the loudest thing in the room or the quietest. A painting can reveal enormous technical skill but be emotionally cold, or be crudely rendered but emotionally acute; it can feel as cruel as a slap in the face or as delicate as a feather. Some art is so of its time that ten years after its completion it can appear dated, while other works get more interesting as the decades, and even centuries, pass. To my mind, the best collections around are the ones that reflect this kind of diversity.

The Arts Council Collection – which is the largest loan collection of modern and contemporary British art in the world – reveals, in the most wonderful way imaginable, how complicated, rewarding and difficult it is to pin down the relationship between time

and art, and how the evolution of a collection is – quite despite the expertise of the selectors and advisors – as equally shaped by the vagaries of individual taste and sensibility as it is by knowledge. The Arts Council Collection was established in 1946 to support artists living and working in Great Britain by purchasing their work. In the early days these works were made into small touring exhibitions that travelled the length and breadth of the country with the aim of introducing contemporary art to new audiences. One can only try and imagine now how much of a tonic, what a sense of life, possibility and freedom art offered to the traumatised population of Britain of the late 1940s and early '50s. However, the impulse for the Collection wasn't just about audiences. The remit was to collect paintings, sculptures, prints and drawings by British artists at an early stage of their career, a gesture that was – and continues to be – not only a gesture of faith in their talent, but also an important way of financially supporting artists. (In recent years, the Collection has broadened its remit to include any artists from around the world who live and work in Britain, of which there are thousands.) A 'museum without walls', works from the Collection are regularly exhibited in touring exhibitions and loaned out to government departments, hospitals, universities and other civic buildings throughout Britain. The Collection now comprises almost 8,000 works of art, around 2,000 of which are paintings; it's a brilliant reflection of the creativity that has flourished in Britain over the last hundred years or so. Since its inception, the Collection has acquired works with the help of an Acquisitions Committee, which at any one time comprises a writer, an artist and a curator. In my capacity as a writer, I was honoured to be on the Advisory Committee from 2011 to 2013.

My initial response to the very kind invitation from the Arts Council Collection to curate an exhibition from these works was: 'I am not a curator!' Thankfully, this didn't seem to worry them: as they reminded me, I studied painting, and have written a lot about art – both historical and contemporary – for various books, catalogues and magazines (predominantly *frieze* magazine, which I have edited for over a decade). As you would be a fool not to jump at the chance to explore this extraordinary collection, I agreed to come up with an idea for an exhibition. The more I looked, the more excited I became about the possibilities of a large show of figurative painting – a genre which has always fascinated me – that would span the Collection's history and embrace and reflect its very particular personality: one that is as hard

to define as it is easy to admire. Although it was started in 1946, the Collection contains work from as far back as the late nineteenth century and, alongside very well known works by artists such as Richard Hamilton, David Hockney, Paula Rego and Walter Sickert, it contains wonderful paintings by lesser-known artists, many of whom I previously hadn't heard of. In this sense, becoming familiar with the Collection has been an incredible education for me about the development of British painting.

So, what determined my choices? I have long been fascinated with what the infinite imaginable approaches available to figurative painters reveals both about the possibilities of paint and what it means to be a human being in the here and now. However, rather than predetermining a theme and then choosing paintings to fit into it, I wanted to approach the show from the other way around: to allow the paintings themselves to shape my thinking.

Looking through the Arts Council Collection, I realised that time and again I was drawn to the pictures that offer a unique worldview – not necessarily the ones that tell the accepted history of art (although they are of course important) but the ones that side-step the canon, if you will too, or that are surprising, skilful, imaginative, inventive or affecting. After a while, I began to recognise a thread: many of the paintings I was attracted to represent a space that evokes something theatrical, in the broadest sense of the word; they also hint at some kind of narrative. Of course, in many ways perhaps all figurative artists are storytellers and all of their art is, to a certain extent, theatrical. After all, people exist in these paintings to be looked at and interpreted, and their gestures – however small – can have a great significance. As Paula Rego explains in a short piece she wrote for this book: 'Why do I paint figuratively? Because it is easier to tell a story figuratively than with lines and blobs: I can only tell a story that way.'

In some of the paintings, for example *Box at the Lyceum Theatre* (c.1932) by Walter Bayes, the space described is literally theatrical. (An interesting aside: in 1901 Bayes painted scenery for a production of Henrik Ibsen's 1896 play, *John Gabriel Borkman*, and his work in the first Camden Town Group exhibition in 1911 included costume and scenery designs.) In other paintings this theatrical space is more oblique, as in William Roberts' *The Seaside* (c.1966), which depicts a group of tightly choreographed people on a beach. The theatre of everyday life is represented by many of the artists in this exhibition. In Ryan Mosley's *Northern Ritual* (2011), for example, a group of women, dressed in leotards and shifts with big hair and their

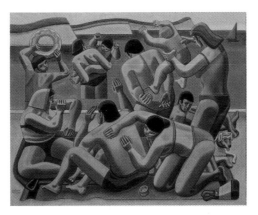

WILLIAM ROBERTS
The Seaside
c.1966

faces obscured, enact a mysterious ceremony that recalls both Dada theatre and women getting dolled up for a night out; in Rego's *Sleeping* (1986), a group of girls and pelicans are frozen in a moment of dreamlike interaction; in Lynette Yiadom-Boakye's *Condor and the Mole* (2011), two children pause on a beach and gaze at a rock pool – we catch them mid-conversation, their gestures as frozen as a film-still. All of these images reiterate the long conversation that has been taking place for centuries now between painting and theatre, each medium inspiring, even egging on, the other. Painters often influence set designers – and indeed, many painters have themselves worked as set designers, including Bayes, but also Hockney and Peter Unsworth, who had a long career designing sets for the Royal Ballet – and for centuries, artists have distilled the live experience of theatre into a single image.

More generally speaking, figurative painting – in its distillation of a moment observed – could be seen as a kind of one-act play: one in which the actors are permanently stilled in the midst of an evocative, often enigmatic gesture. Despite the difference between a three-act structure and a single image, both approaches share something fundamental: they're at once intimately connected to, even dependent upon, their audience, yet they also keep it at arm's length: obviously, you can never join the actors on stage or leap into a painting – the only way to get close to them is to allow your imagination and your intellect to absorb and process what it is they are attempting to communicate to you.

Approaches to figuration in *One Day, Something Happens* vary wildly. The people represented in these paintings are young, old, fat, thin, recognisable or obscured; some are portraits (paintings by Jeffery Camp, Richard Hamilton, Michael Fullerton), while others are inventions (Yiadom-Boakye, Georgia Hayes, Jock McFadyen). In paintings such as the exquisite, light-filled Lucian Freud portrait from 1954, *Girl in a Green Dress*, and Barbara Walker's wonderful painting of a man getting a haircut, *Boundary I* (2000), the artists have rendered their subjects with near photographic clarity, while in others – such as Glenn Brown's *Decline and Fall* (1995), Katy Moran's triptych, *Freddy's Friends* (2006) and Phoebe Unwin's *Sleeper* (2012) – figures dissolve into the paint almost to the point of abstraction. In some pictures, such as the surrealist Eileen Agar's *Poet and his Muse* (1959), a body has become a series of patterned, interlocking fragments, an embodiment, perhaps, of the idea that what we are is more complicated than what we see. Rose Wylie sums up her reasons for choosing to paint

RICHARD HAMILTON
Portrait of Hugh Gaitskell as a Famous Monster of Filmland
1964

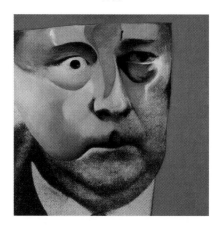

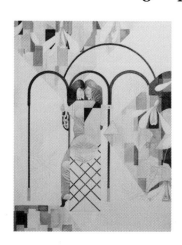

DONNA HUDDLESTON
Untitled
2010

figuratively in the text she wrote for this book, stating that: 'With abstract art, no one can see quite what you're bringing in, as it's not clear where you start from, especially without a text. Figuration pulls in more possibilities, more either/ors, more anxious decision-making.' Perhaps it's this anxious decision-making that lends so many of these pictures such a compelling tension. Glenn Brown takes this idea of tension a step further, wanting his paintings to evoke something akin to a haunting. In his text in this book, he states that: 'I wanted the figure to breathe down the back of your neck, to be – although not exactly alive – always present.'

The earliest work in *One Day, Something Happens* is a beautiful 1906 study of a woman by Sickert, her forehead patterned like a diamond; the show then wanders through the decades, visiting along the way paintings by artists as diverse as Robert Colquhoun (*Seated Woman and Cat*, 1946), Prunella Clough (her vision of *Lowestoft Harbour*, 1951), and Richard Hamilton and David Hockney in the 1960s. The present is represented by a group of fantastically interesting figurative works by contemporary artists including Enrico David, Michael Fullerton, David Noonan, Renee So, Martin Westwood and Lynette Yiadom-Boakye. Many of these later works are the result of what could be called 'post-painting', i.e. work that is informed by painting but isn't simply oil on canvas. Donna Huddleston, for example – who, incidentally, also trained as a set designer – creates filmic dreamscapes of women in watercolour; Enrico David has built a quasi-puppet theatre; and Steve Claydon has extended a two-dimensional image into a free-standing screen and sculpture. Yet painting is a touchstone for all of them. Renee So's work might be knitted, yet she described her approach to me as making 'paintings in wool'. Similarly, Noonan declares in the text he wrote for this book: 'Painting is the foundation of how I think about making pictures.'

The great Sickert was a starting point for my selection in a thematic way too; his legacy filters through much of the exhibition. He was an artist who was restlessly open to the possibilities of what art could be. Born in Munich in 1860 (many of the artists in the Collection weren't originally from the UK), he was not only a painter and printmaker but also a respected art critic; he trained as an actor and loved the theatre and the music hall, which he painted again and again. He was also fascinated by developments in photography, and was criticised for using photos as a basis for some of his paintings, a practice that many contemporary artists in the show – such as Glenn Brown, Milena Dragicevic and David Noonan – employ.

Sickert was also passionate about representing working-class life, declaring repeatedly that he was more interested in the kitchen than the drawing room – and looking over my selection, I have realised what a dearth of drawing rooms we have. Walter Bayes was, like Sickert, an art critic as well as a painter, and he too was a founder member of the Camden Town Group, of which Sickert, of course, was a leading light. Interestingly, Malcolm Drummond, whose painting *Brompton Oratory* from 1912 was one of my first choices for the show, was taught by Sickert: in 1910, when Drummond was 30, he became one of Sickert's first pupils at his new art school, Rowlandson House, which ran from his home in Camden until 1914. Around the same time that Drummond was painting *Brompton Oratory*, Alfred Wolmark was painting the beautiful *Woman with a Bowl of Fruit* (1913) – a painting that was a revelation to me when I first came across it in the Collection. This exquisite work is a study in both understatement and invention, in which the intimation of a woman – her face a thoughtful smudge framed by her deep blue hair – shines softly, full of life; her patterned blue gown glows against a deep red background, interrupted by slashes of colour, like smashed, smouldering jewels. Wolmark was born into a Jewish family in Warsaw in 1877; he moved to London and became a British citizen in 1894 and became part of the so-called 'New Movement' in art. It is unclear whether he knew Bayes, Drummond and Sickert personally, but there is an obvious connection in their approach to picture-making.

Although the Camden Town Group altogether only held three exhibitions (in 1911 and 1912), their focus on modern life, and their acceptance of different stylistic approaches (as long, that is, as the artist shared their commitment to representing contemporary life in all of its mucky glory) was as radical then as it is relevant now. Even today, Lynette Yiadom-Boakye cites Sickert as an influence. The subjects so dear to the Camden Town Group – eating, drinking, performing (either for one person or an audience), sleeping and dancing – are all subjects that Yiadom-Boakye returns to again and again.

It is a truism that every artist is in conversation with the ones who came before them, and with their contemporaries. Glenn Brown's painting *Decline and Fall* (1995) is based on a group of paintings by Frank Auerbach; Rego cites Goya as an influence; Ryan Mosley has looked deeply at Sidney Nolan; Noonan mentions Philip Guston; and Rose Wylie has declared influences as disparate at Walt Disney and El Greco. The various references to different art

movements – from portraiture to abstraction, minimalism to pop – in David Hockney's great work, *Portrait Surrounded by Artistic Devices* (1965), is a case in point. It's a painting about the intersection of paint and people – or, in other words, about influence, both personal and professional. It's at once a literal portrait of Hockney's father and a more oblique one of the artists who influenced his painting: Paul Cézanne (indicated with the cones) and Francis Bacon (who is paid homage to in the pink ground). It's also a 'portrait' of a struggle between abstraction and figuration: the artist's feelings about his father mingle with his struggle to discover the most appropriate language to express his feelings not only about someone who is important to him, but about art itself. And so the conversation continues.

I must say, it was very hard to limit this show to around 40 works, which, to my mind, is a very good sign. Such an extraordinarily diverse cross-section of approaches and sensibilities in this Collection makes it very clear how painting, rather than being the exhausted, anachronistic medium it is sometimes accused of being, is in fact one that adapts well to the rapidly changing world we live in. If the Arts Council Collection is anything to go by, painting is thriving, its possibilities still infinite. But then, that shouldn't surprise us; since someone first painted a picture of a person on the wall of cave, painting has always been a contemporary medium.

To paraphrase Sickert, I selected the works for this show quite simply because when I looked at each and every one of them, something happened: something magical, moving, intriguing or perplexing, something that both said something about the time in which it was made while remaining relevant to our own complicated present. Whatever it was, it was so compelling that it made me, quite simply, want to keep on looking. I hope you do too.

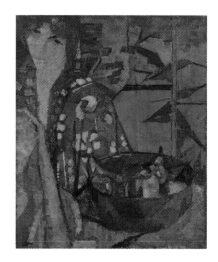

ALFRED WOLMARK
Woman with a Bowl of Fruit
1913

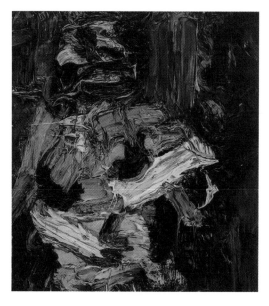

GLENN BROWN
Decline and Fall
1995

Works

WALTER SICKERT
(b. 1860, Munich; d. 1942, Bath)
Head of a Woman
1906

Walter Sickert is considered one of the most influential British artists of the early twentieth century. His artistic career began in 1882, when he became a studio assistant to James McNeill Whistler. In 1883 he couriered Whistler's celebrated *Portrait of the Artist's Mother* (1871) to Paris, which led to an introduction to the work of Edgar Degas. Sickert became one of Britain's chief proponents of modern ideas about painting being developed in France and came to believe that most contemporary paintings were too sentimental and that art needed to embrace a more honest, darker representation of reality. *Head of a Woman* is also sometimes known as *The Belgian Cocotte* on account of her exposed breast; indeed, Sickert often used prostitutes as models in his work. The sitter in this case is a French milliner named Jeanne Daurmont who, along with her sister, modelled for several sittings in 1906. The painting demonstrates the influence of the impressionists; the skin and face of the figure is constructed from dabs of pale yellow and hues of red, pink and ochre, while the dark backdrop is consistent with contemporary photographic portraiture and theatrical lighting.

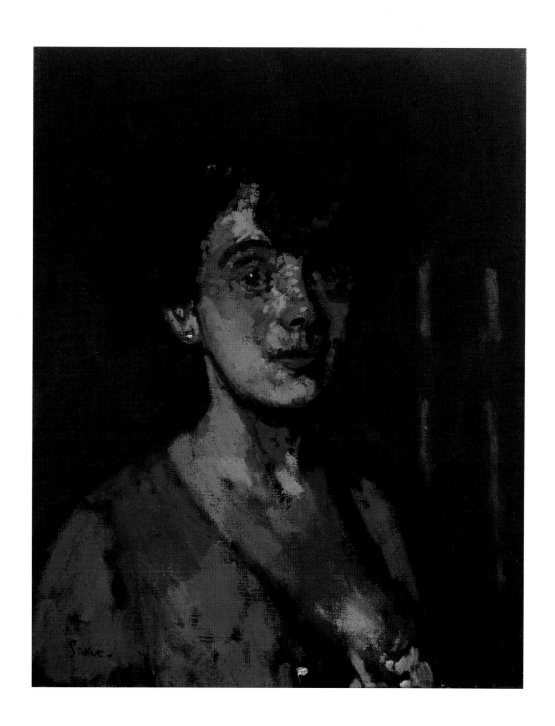

WALTER BAYES
(b. 1869, London; d. 1956, London)
Box at the Lyceum Theatre
c.1932

Walter Bayes was a founding member of the Allied Artists Association, through which he met Walter Sickert – both would later become founding members of the Camden Town Group. Primarily recognised as a critic and teacher, Bayes was also an accomplished artist celebrated for his precision and fastidious approach to painting. His obituary in *The Times* stated that 'it might be an overstatement to say Bayes was too intellectual for a painter, but it is certainly true to say that he excelled in what has been called the science of picture making, including perspective and the proportioning and balancing of colour.' Created while he was working as a lecturer in perspective at the Royal Academy Schools, *Box at the Lyceum Theatre* demonstrates Bayes' commitment to considering an image in its entirety and his rigorous efforts to ensure balance in his paintings, as well as his interest in the decorative arts.

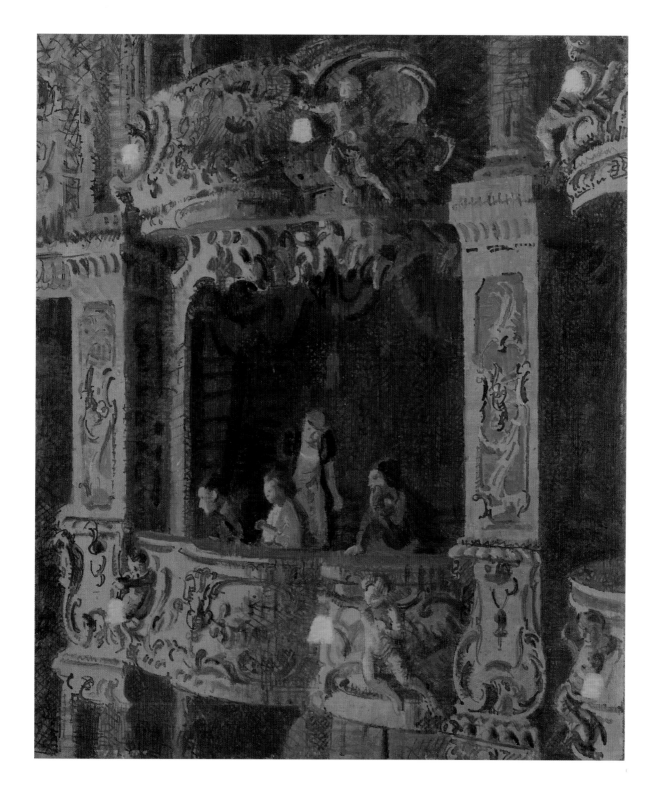

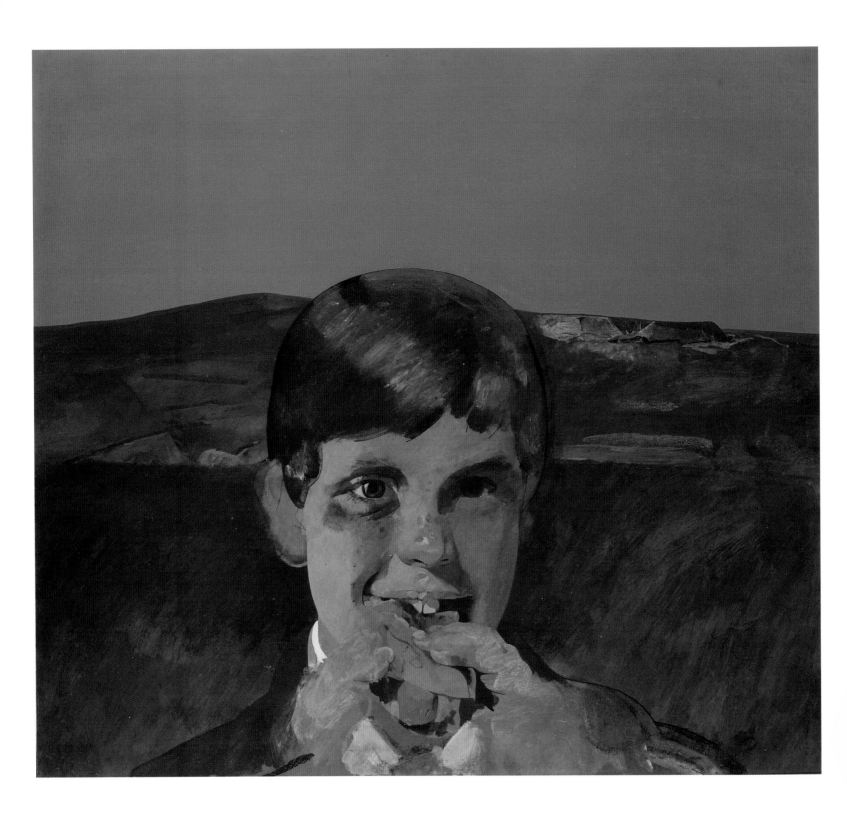

PETER BLAKE
(b. 1932, Dartford)
Boy Eating Hot Dog
1965

Peter Blake is often cited as a founding figure of the
British pop art movement and is noted for his brightly-
painted collage constructions featuring icons of popular
culture past and present. Despite this, Blake has always
considered his core practice to be that of figurative painting.
He studied painting at the Royal College of Art (1953–56),
making a number of oil paintings of anonymous children
surrounded by their favourite things; these works act as
bittersweet revisions of Blake's own troubled childhood
during the war. *Boy Eating Hot Dog* indicates a new direction
and points towards his mature style. By 1965 Blake had
developed an approach to portraiture that involved working
from photographs from a range of sources, particularly
magazines. The subject of the hot dog was most likely
influenced by Blake's first trip to the US in 1963 during which
he made a series of sketches, including of fast-food and
drive-in restaurants. The choice of acrylic is also significant
– acrylic paint had only just been invented and Blake enjoyed
its crisp clarity. Despite an overall sense of detail in Blake's
portraiture, unfinished areas are common, with blurring
around one eye a regular trope – this Blake considers a
subconscious response to his own shyness and to a facial
injury he sustained in a childhood cycling accident.

RYAN MOSLEY
(b. 1980, Chesterfield)
Northern Ritual
2011

Ryan Mosley uses traditional methods of colour production
– grinding pigments and mixing them in binder – allowing
for the vast and varied palettes seen in his work, which is
embedded with references to paintings and styles of the
past, along with an internal lexicon of images and symbols.
Northern Ritual depicts the idea, in the artist's words,
of 'a group of women, possibly mothers, bonded through
the trials of living and raising others, arriving at a venue,
discussing others, but themselves practising some form
of ritual. Not dancing per se, but being part of some form
of dance. On a stage themselves, but in a performance
they hadn't rehearsed'. The composition is accordingly
reminiscent of a theatrical space; the figures at the base
of the composition conjure up an audience for the figures at
the centre, who are surrounded by plants, fronds and leaves
that appear to frame them in a scene.

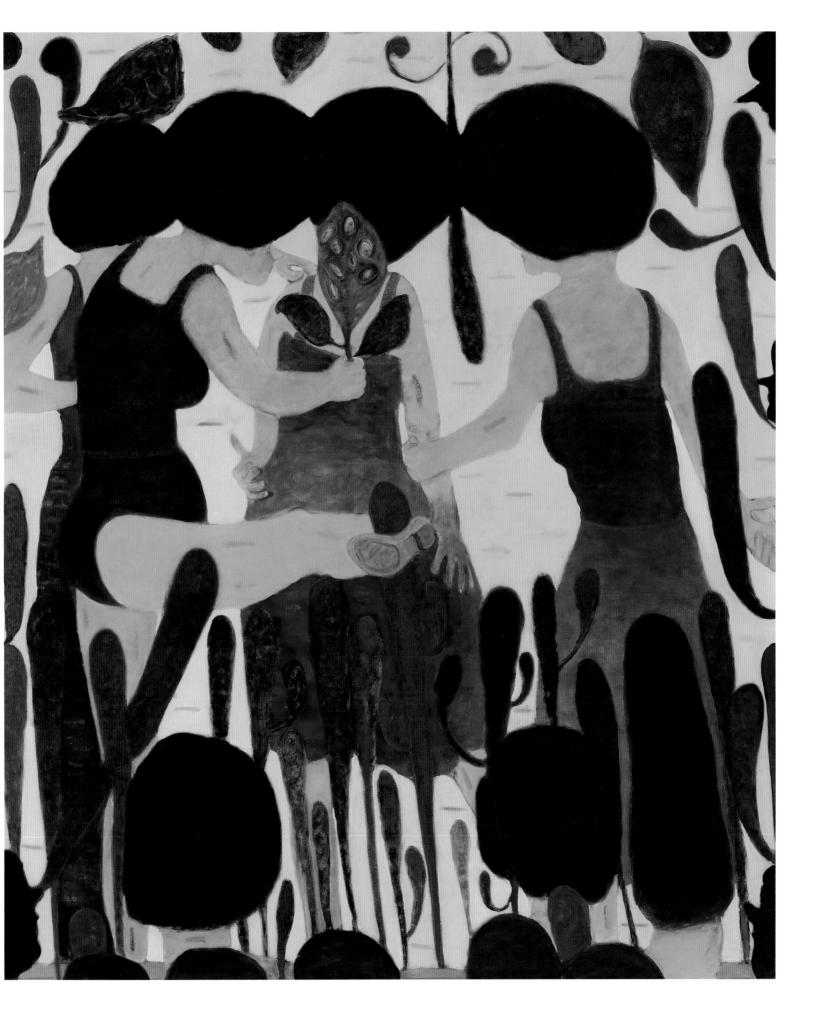

WILLIAM ROBERTS
(b. 1895, London; d. 1980, London)
The Seaside
c. 1966

William Roberts initially planned to train as a poster
designer, but classes at Saint Martins School of Art,
a scholarship to the Slade School of Art in 1910 and
subsequent travels in Italy and France introduced him
to post-impressionism and cubism. Following a period
working at Roger Fry's Omega Workshops – a design
enterprise founded by members of the Bloomsbury Group
– he became involved with the Vorticist movement, which
embraced abstraction as an artistic response to the First
World War. After his gruelling experiences during the war,
his work returned to rounder, fuller, more representational
forms. Despite being regarded as somewhat of a recluse,
Roberts spent most of his career painting and drawing
ordinary people going about their life at home, work
and play. He was particularly drawn to individuals at
leisure. *The Seaside* (*c.* 1966) presents a scene familiar
to British beaches, with holidaymakers, perhaps from
the same family, jostling around the canvas. Some sit on
rugs, applying sun cream, others, carrying small children
or flotation devices, wade into a flat sea intersected by
undulating, grassy cliffs and a small red sailing boat, while
the panting family dog looks on. The strong outlines and
graphic flatness are typical of Roberts' late style, with
the composition of tightly packed bodies and limbs creating
a rhythm and a sense of movement across the canvas.

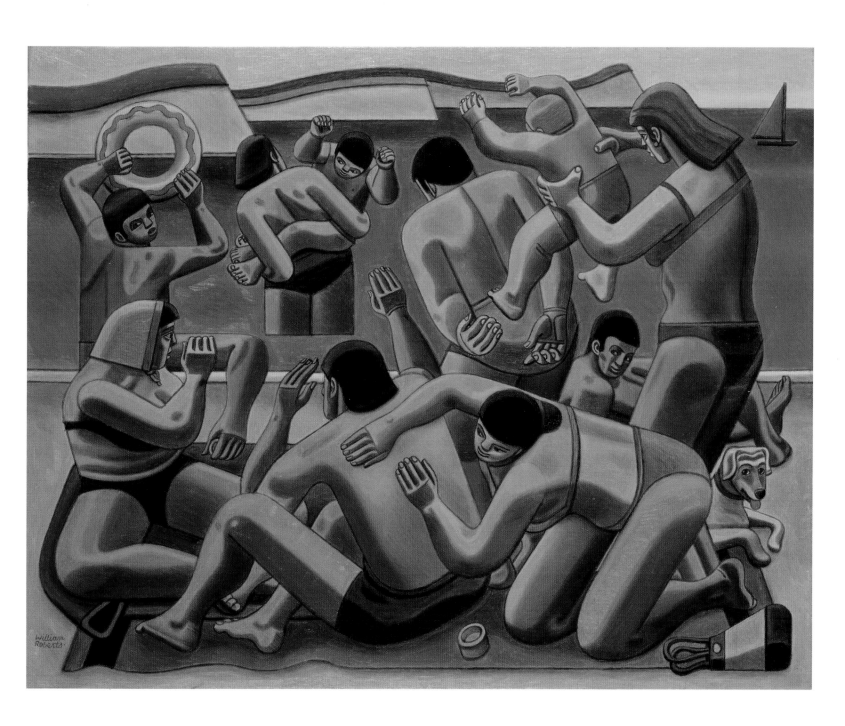

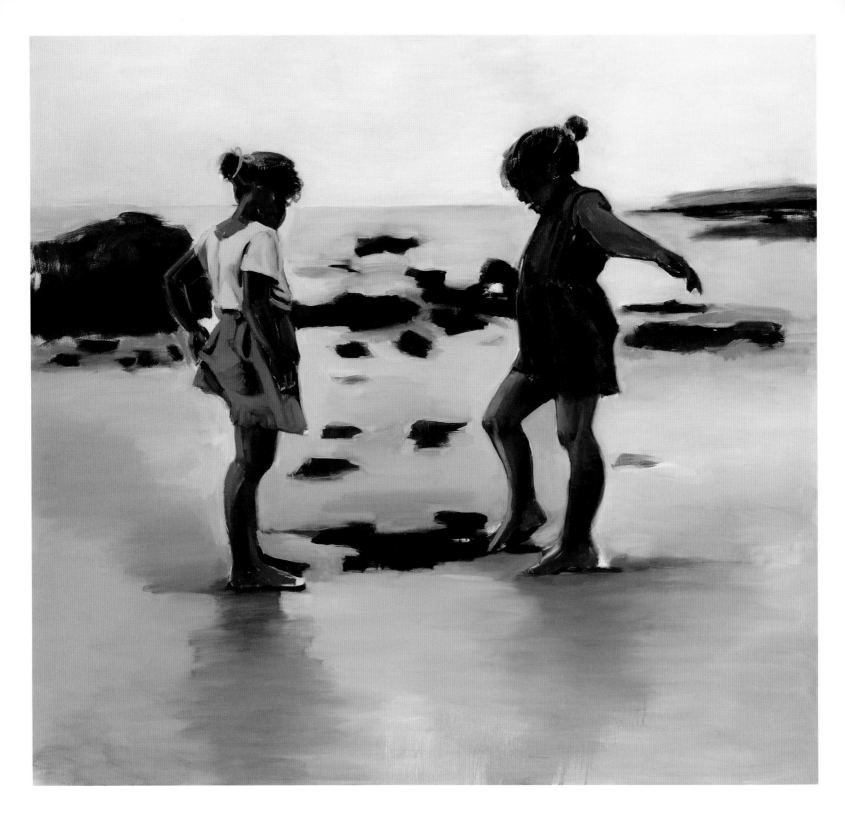

LYNETTE YIADOM-BOAKYE
(b. 1977, London)
Condor and the Mole
2011

When I painted *Condor and the Mole* in 2011, I was thinking about a huge expanse of space, a landscape or seascape with two figures that at once appear large and small. I wanted the space to be white or as light as possible, with white clouds and white sands and the cold, white morning air. Or, perhaps white rocks and chalk dust, as though the two girls were playing on the moon.

I don't often make a lot of preparatory sketches. The under-painting is the preparatory sketch. I find it more useful and logical to plan the painting using paint. I've always found it distracting to work from a detailed drawing; it's a bit like having to translate a passage from French to English before you can read it. So much gets lost in translation between my drawings and my paintings. Quite simply, the drawings work on their own terms, in their own language, as do the paintings – when they work at all, that is.

I always start with under-painting, laying down the tones and colours. I work out where I want everything to go, and how and where different tones and colours should bleed through, or define, the composition. This is particularly important, as I use the whitest white for the ground; any subsequent layer or mark on it will be affected by the trace of another colour on the brush or palette. I rarely ever want the white marks to be completely pure. I can never achieve a brighter white than the ground. Every mark is relative to that ground.

I very rarely paint children, or rather the figures in my paintings are seldom recognisable as youngsters. In the works that I can recall, children are usually engaged in some action or movement. Another painting of mine, *Firefly* (2011), relates to *Condor and the Mole*: it's three boys running on a beach. Perhaps I'm a little wary of depicting children because it can very easily slip into nostalgia, which isn't really what I'm after. But as I mentioned earlier, there is something about the small appearing large that makes children apt for this composition. I wanted to think about their power in a different way; about their activities, ideals and conspiracies as potential power.

Lynette Yiadom-Boakye

GEORGIA HAYES
(b. 1946, Aberdeenshire)
SAVED BY DROWNING
(SICILIAN FOUNTAIN 2)
2013

The subject of Georgia Hayes' paintings are friends, animals and objects, particularly sculptures and artefacts from other eras and cultures, that have made a direct visual or emotional impact on her. Her recent paintings have drawn particularly on Western, Middle Eastern and Ancient Egyptian cultures. The paint, colour and form of the source material dictates how her work evolves, with Hayes aiming to paint with a freedom and fluidity that allows for the unpredictable. *SAVED BY DROWNING (SICILIAN FOUNTAIN 2)* is the second painting in a series of three inspired by drawings Hayes made of a fountain in Ortigia in South East Sicily. The figure featured in the fountain is Artemis, the Greek goddess of hunting, childbirth and the wilderness, and Arethusa, the chaste river nymph. In the original myth, Arethusa, while bathing in a cool river, was observed by the river god, Alpheus, who fell in love with her. Fleeing Alpheus, Arethusa sought the protection of Artemis who transformed her into a spring, which now bears her name in Ortigia. Hayes uses vivid colours and striking forms to reinterpret the story, creating a simplified graphic language to re-interpret the eroticism and fantastic nature of the original story.

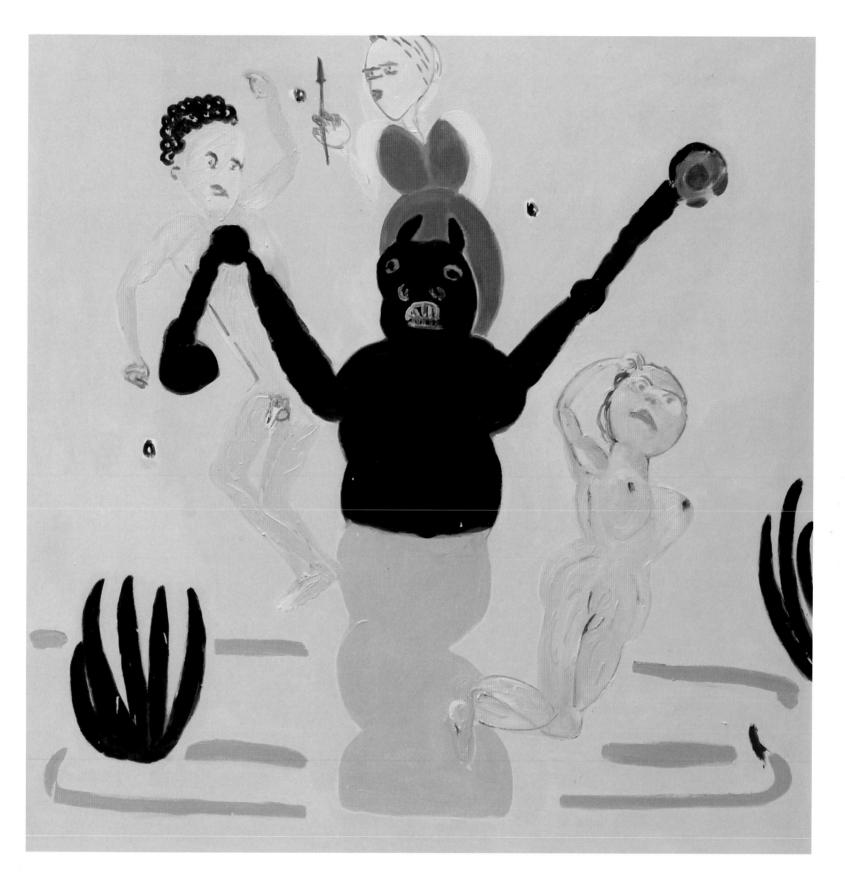

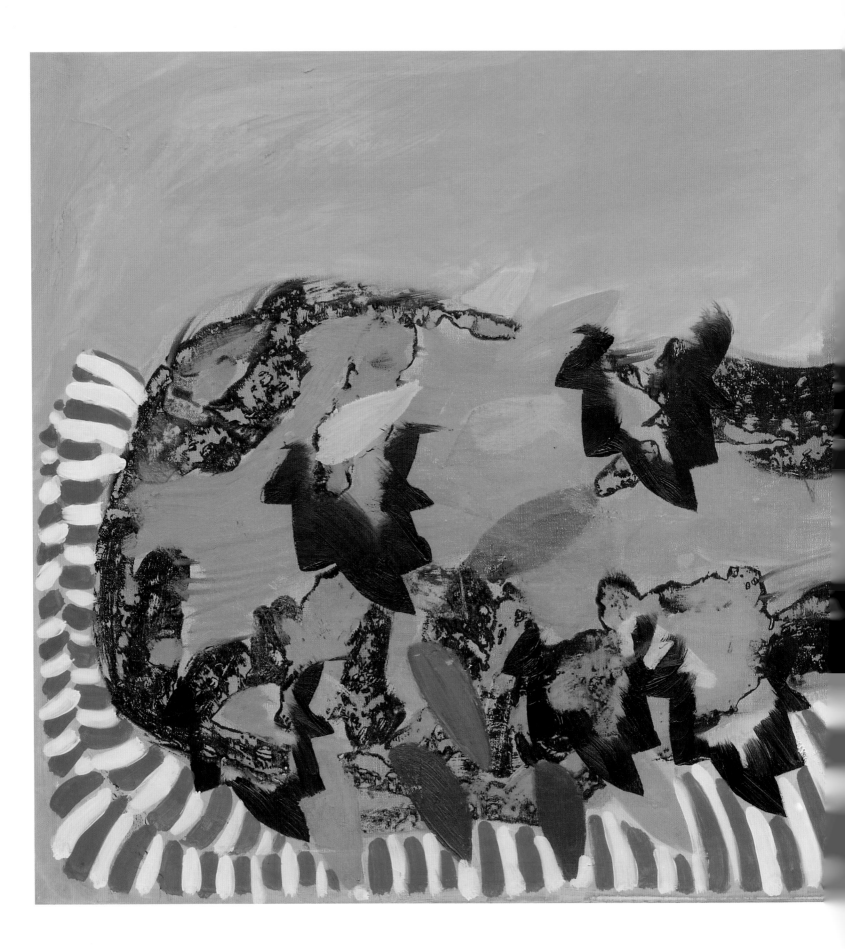

PHOEBE UNWIN
(b. 1979, Cambridge)
Sleeper
2012

Phoebe Unwin's works are based on memory and the evocation of universal experiences and sensations; in the artist's words, 'I am not interested in reproducing familiar images. When I approach my subjects, I like to think of visually explaining what something feels like, rather than what it looks like.' For this reason, the images she makes are largely abstracted, calling attention to the textural and sculptural qualities of the paint used in their composition. *Sleeper* depicts a horizontal figure, roughly composed of sweeping, pinkish flesh tones, lying atop layered blue-and-white-striped forms that sink under its weight. The abstracted body features several near-repetitions of the same sharply-delineated shape, which resembles a sleeping profile. In keeping with the artist's approach to representation, it could be said to demonstrate the immersive, intimate and enveloping qualities of sleep and the manner in which sleeping 'selves' are contained and diffused. As Unwin stated, 'When I made *Sleeper*, I was thinking of how it feels to lie opposite someone, looking at them sleeping; how their shut-eyes and facial expression mean their body is with you but their mind is not.'

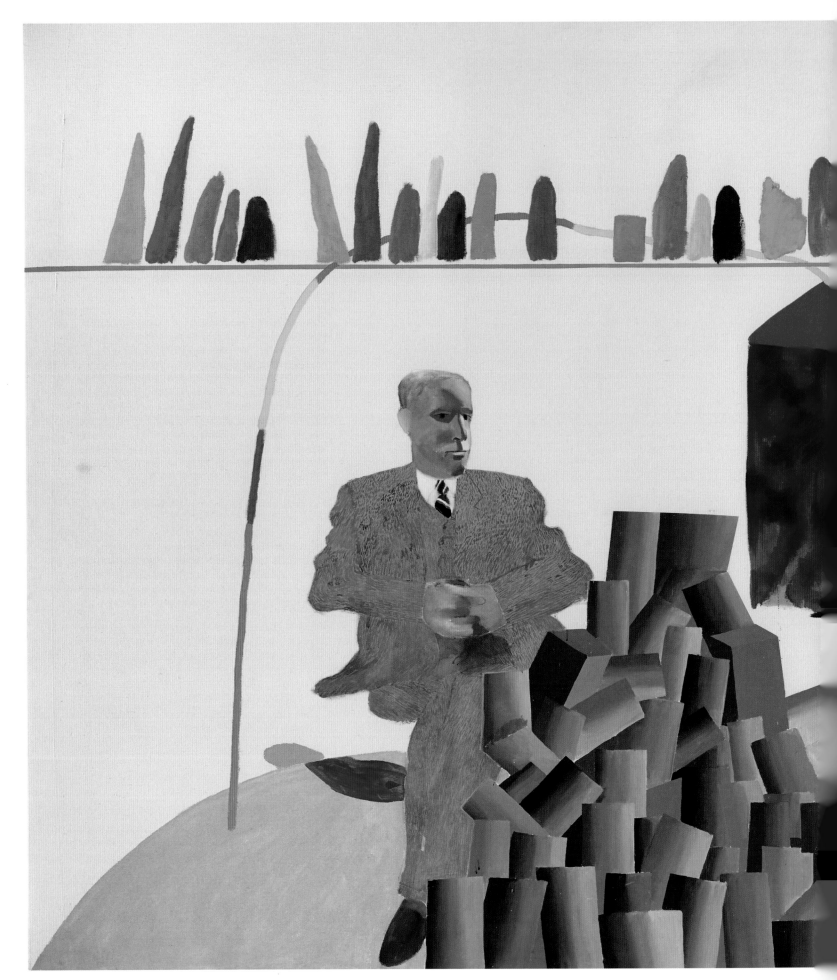

DAVID HOCKNEY
(b. 1937, Bradford)
Portrait Surrounded by Artistic Devices
1965

Friends and family are frequently the subjects of David Hockney's portraits, with his mother, Laura (1900–99), a particular favourite over several decades. Here, the sitter is his father, Kenneth (1904–78), who was well known in Bradford for his strong political views and eccentric character. As Hockney noted, 'he taught me not to care what the neighbours think'. Based on a drawing made from life, he is affectionately painted in the smart clothing he liked to wear. Surrounding him are various 'artistic devices' showing different styles of painting, playing with colour, shape, depth and geometry. These forms are references to other artists' work, in particular Paul Cézanne who talked about treating nature in terms of 'the cylinder, the sphere and the cone', while the flat, abstract brushstrokes on the two-dimensional shelf and the colourful shapes refer to contemporary abstraction. It has been suggested that this work is an oblique criticism of modernism, with Hockney implying that the human element of art, as represented here by a loved parent, should not be overwhelmed by adherence to theory.

RENEE SO
(b. 1974, Hong Kong)
Drunken Bellarmine
2012

Renee So populates her works with figures drawn from
clashing cultural sources: Victorian top hats and facial
hair, the pantaloons of Dutch and Portuguese traders in
16th- and early 17th-century Japanese paintings, the card
tricks and theatrics of traditional magic shows and comedic
performances. A recurring feature of her work is the two-
faced bearded figure portrayed in *Drunken Bellarmine*; the
topmost face is simultaneously reflected and reversed at
the centre of the beard, reminiscent of the 'king' and 'jack'
figures found on playing cards. The 'Bellarmine' of the title
refers to the stoneware vessels for ale and wine imported
from Germany from the 1500s to the 1700s. These were
moulded with bearded faces and named after Cardinal
Roberto Bellarmino (1542–1621). Severed and slumped
over a vertically-striped block, the figure resembles a
character from a slapstick comedy, drunkenly lolling in
what might be a puddle of wine or its own blood. So's works
are executed using a knitting machine, precisely translating
the artist's line illustrations and flat colour planes into
large panels. Although the art of knitting in wool is an
ancient one, the staggered lines and blocks the technique
creates suggests the pixels of a computer screen.

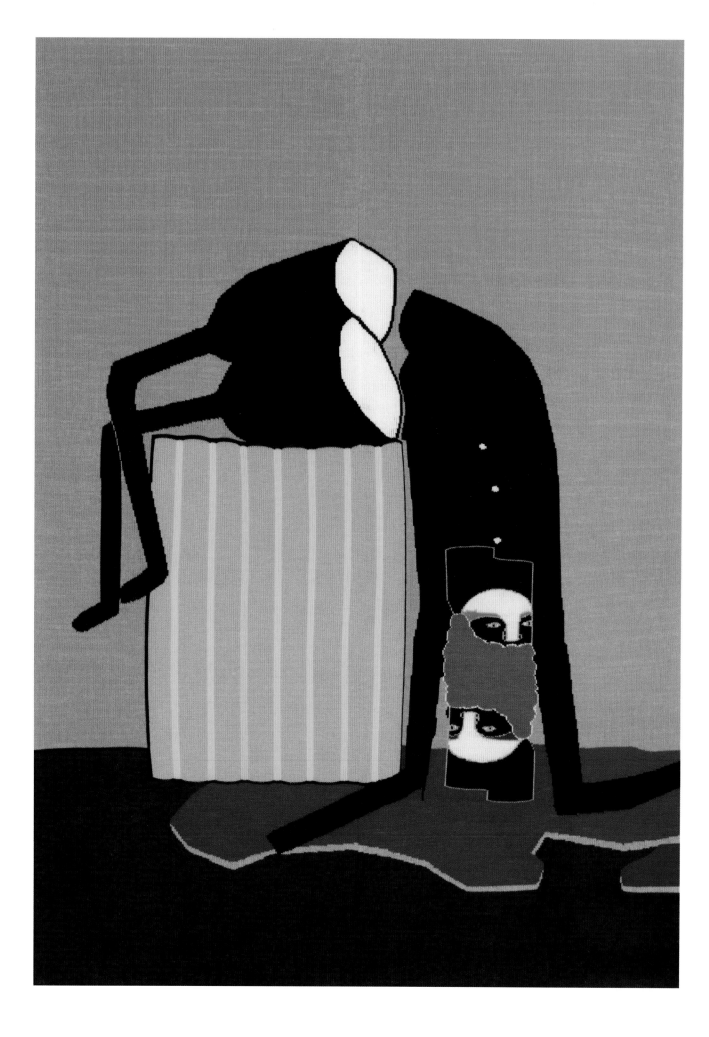

ROBERT COLQUHOUN
(b. 1914, Kilmarnock; d. 1962, London)
Seated Woman and Cat
1946

Bought in 1946, *Seated Woman and Cat* was one of the Arts
Council Collection's earliest acquisitions. It was painted by
the Scottish artist Robert Colquhoun during the height of
his renown, when he was associated with other members
of the School of London, such as Lucian Freud and Francis
Bacon. Colquhoun trained at the Glasgow School of Art,
where he met fellow painter Robert MacBryde. The pair,
known within the London artistic scene as 'the two Roberts',
formed a romantic and creative partnership that lasted
until Colquhoun's death. His style was highly influenced by
Pablo Picasso, Jankel Adler and Wyndham Lewis and, like
Freud and Bacon, his central theme was the isolated figure
and the existential questions it raised; a theme evident in
Seated Woman and Cat. He was also a prolific printmaker,
an interest that he developed after he left London for Lewes
in 1947. Despite early acclaim, he died in relative obscurity
in 1962 after a long struggle with alcoholism; MacBryde just
four years later in a traffic accident.

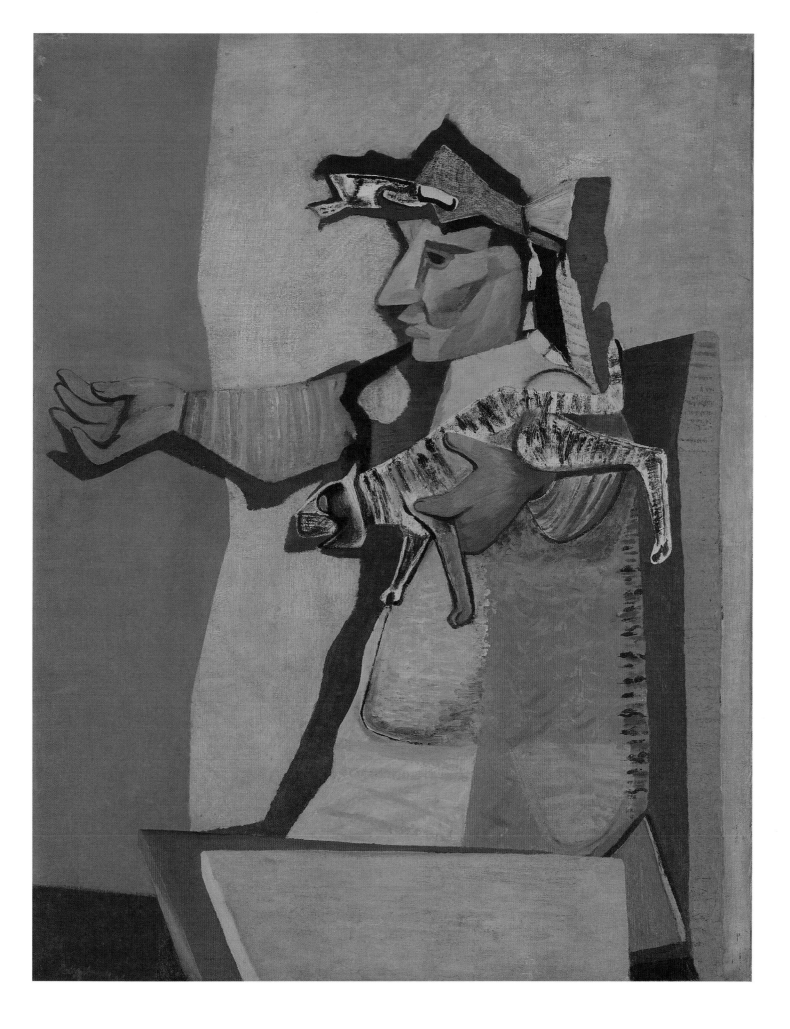

MILENA DRAGICEVIC
(b. 1965, Knin, former Yugoslavia)
Supplicant 101
2008

I don't think I ever made a decision to paint. I do know I made
a decision to become an artist and painting somehow naturally
followed. I would describe myself as an artist who uses a code
of abstraction but tries to keep one foot in reality. The question
of abstraction versus figuration in painting is something that
completely perplexes me and I usually just ignore it. I began my
ongoing 'Supplicant' series in 2006 because at the time I needed a
simple starting point. De Kooning once said that nothing could be
simpler than a circle in the middle of a canvas and I thought that
a face could be that simple device. Faces are voids or protrusions
where an intervention or interception can occur: it is that which
I am painting and not the figure per se.

The models I choose are usually female friends or acquaintances.
I start with photographic headshots and the more I do, the more
it feels performative because I am aware of the power of the face
in that it is both viewer and viewed. I eventually pick one image
that lends itself well to intervention and then drawing helps
me understand how the intervention may play out. I mainly use
tracing paper because it allows for speed when redrawing and
dissecting forms. I do accept that once painting begins, U-turns may
become necessary. My interventions or interceptions are moments
caught in a process of unfolding and refolding both my material
and intuition. It's like trying to capture the passage of possible
objects or fragments and never needing to know how you got there
in the first place. The 'Supplicants' are not psychological studies
or portraits but 'stand-ins' for something else. They are not masks,
mutants or hybrids. They are simply unknowable.

I am not really influenced by many painters. I tend to look more
at sculpture, design, architecture, film and ancient art and I often
borrow from marginalised artists. I love looking at cheap catalogues
from shows that no one remembers. I want to work with something
that already exists in the real world and I've come to think of my
work as silent collaborations but with a 'tag-team' attitude. The
'Supplicants' and my more recent series 'Erections for Transatlantica'
(2011) and 'Pampero' (2014) act as an anachronistic place where
something always happens. Hopefully they provide spaces or
loopholes to be borrowed and reconfigured by other artists.

Milena Dragicevic

MICHAEL FULLERTON
(b. 1971, Bellshill, North Lanarkshire)
Katharine Graham
2008

The work of Michael Fullerton encompasses sculpture, printmaking and portrait painting, an apparently contradictory set of artistic approaches that are connected thematically by an interest in communication and the transfer of information in the modern age. The subject of Fullerton's portrait is Katharine Graham (1917–2001), one of the first female media magnates in the United States. Graham acted as publisher and then chairwoman of the *Washington Post* between 1963 and 1991, a period during which the paper was at its most influential, famously breaking the Watergate scandal that led to the resignation of Richard Nixon. Fullerton's portrait suggests a traditional portrait painted from life, but was in fact created seven years after Graham's death. This approach is part of Fullerton's interest in oil painting and how it now sits within the wider spectrum of mass media and augments or competes with our understanding of image dissemination in the information age.

JEFFERY CAMP
(b. 1923, Oulton Broad, Suffolk)
Laetitia Picking Blackcurrants
1967

Jeffery Camp is a painter whose work often depicts the landscape of the UK, particularly the coast of Southern England. Figures frequently feature in his pictures, sometimes banished to the edges of the picture frame, but more often naked and sometimes floating above well-known landmarks, from Venice to Beachy Head. The latter, steep chalk cliffs near Hastings in Sussex where Camp lives and works, are a recurring theme in his work, representing beauty and mortality, as both a natural wonder and a notorious suicide spot. Camp regularly experiments with the scale and framing of his works and the alignment of the picture frame, creating small ovoid and diamond-shaped pictures alongside large asymmetrical canvases. The painting *Laetitia Picking Blackcurrants* is characteristic of these strands, featuring a bent figure in a landscape, framed by a triangle and then the round form of the canvas. The figure in the painting is his then-wife, the painter Laetitia Yhap, picking blackcurrants naked in an East Anglian garden. As with much of Camp's practice, the image contrasts what he sees as the 'classical' elements of his work (geometric forms and accomplished draftsmanship) and the 'lurid, which is more like dream', evident here in the pastoral and erotic resonance of the figure in the garden.

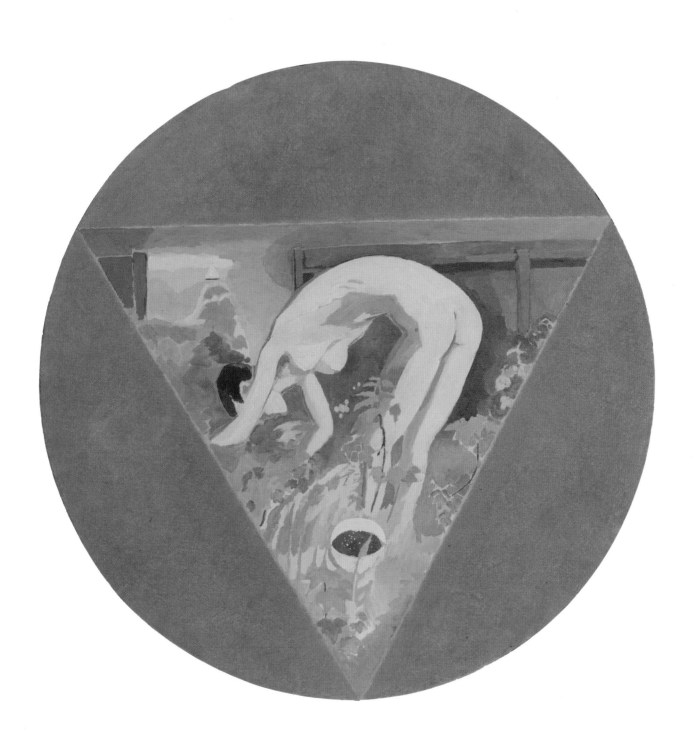

MICHAEL ANDREWS
(b. 1928, Norwich; d. 1995, London)
Study of a Head for a Group of Figures No.10
1968

Michael Andrews is usually linked to the so-called School of London, a group which included Lucian Freud and Francis Bacon and shared a preoccupation with painting the human figure in order to investigate 'the nature of being'. *Study of a Head for a Group of Figures No.10* is one of two preparatory studies in the Arts Council Collection for the large group portrait, *The Lord Mayor's Reception in Norwich Castle Keep on the Eve of the Installation of the First Chancellor of the University of East Anglia* (1966–69). Commissioned in 1965 by the Castle Museum in Norwich, Andrews proposed painting the civic reception for Lord Franks, the University Chancellor, rather than the formal portrait first mooted. Andrews usually resisted painting official portraits, but his suggested format allowed him to indulge his fascination with parties and social interactions, specifically here in the context of the Norfolk society into which he was born. To create the large painting, over two metres high and wide, he worked from photographs of the event, composing a detailed collage of the party in the castle's magnificent Norman keep. He then used a method, devised by artist Nigel Henderson (1917–85), to project and print the collage onto linen, which was stuck to the canvas and painted over. The picture took three years to complete, in part because of the deaths of both of the artist's parents during this period.

ALASDAIR GRAY
(b. 1934, Glasgow)
Juliet in Red Trousers
1976

Alasdair Gray is an artist and writer whose work is strongly
influenced by his socialist worldview. He trained in design
and mural painting at the Glasgow School of Art, and his
novels include *Lanark* (1981) and *Poor Things* (1992).
Juliet in Red Trousers, which depicts Juliet Bochner,
a friend of the artist's, began life as a drawing on paper
made during the first sitting with the model; the figure
was cut out and pasted on board, upon which oil paint
was layered meticulously during subsequent sittings over
the following weeks. The long portrait, slightly cropped
at either side, engagingly positions the viewer directly
opposite the sitter, perhaps rendered more striking by the
fact that her face is turned away. The largely blue backdrop
– composed of the patterned chair and carpet – provides
a balance to the illuminated skin and red trousers. The
chair featured in the painting appears in many subsequent
portraits, such as *Untitled* (2008), where it is seen
reupholstered in dark green fabric.

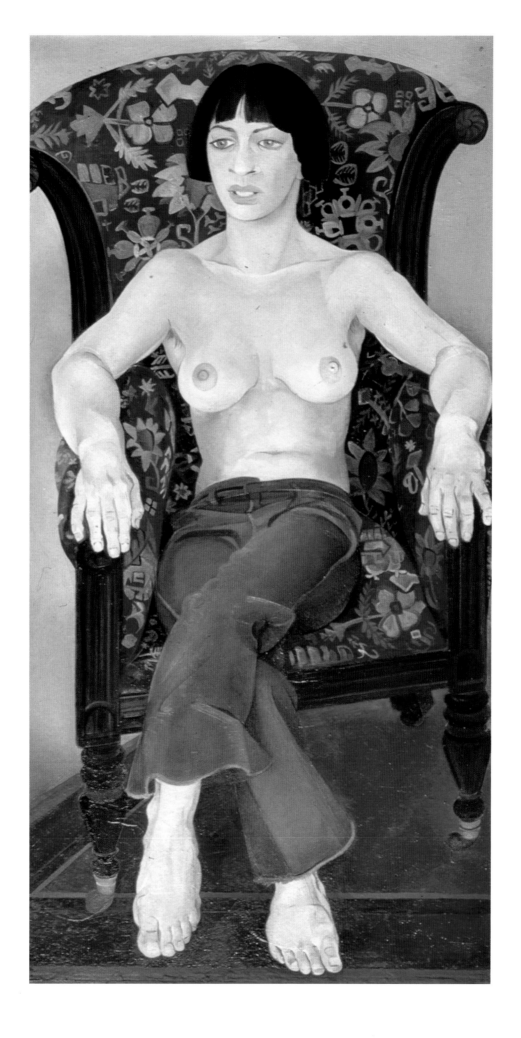

DONNA HUDDLESTON
(b. 1970, Belfast)
Untitled
2010

Donna Huddleston's work builds on her strong foundation
in draughtsmanship and stage design; she graduated with
a Bachelor of Design from the National Institute of
Dramatic Art, Sydney, and her film and theatre design
credits include work on the sets of *The Matrix* and *Moulin
Rouge*. The influence of performance and temporary
spaces is clearly evident in *Untitled*: it is the second
image produced in a body of work based around a musical
performance that is played on the triangle, itself a re-
interpretation of the performances of German Expressionist
dancer Mary Wigman (1886–1973). According to the artist,
it is 'an exploration of the stage-craft techniques used to
depict acts of magic, ritual and transformation'. Against a
sparse backdrop of wooden arches, the two-headed figure
at the centre of the composition holds a triangle and wand,
which emit triangular projections that encompass flowers,
layered colour-blocks and leaves. The soft palette and
subtle gradations of watercolour and gouache reference
hand-drawn visualisations of stage and costume design,
while the knowing expressions on the theatrically made-up
faces of the central figure suggest dramatic plots, secrets
and transformations.

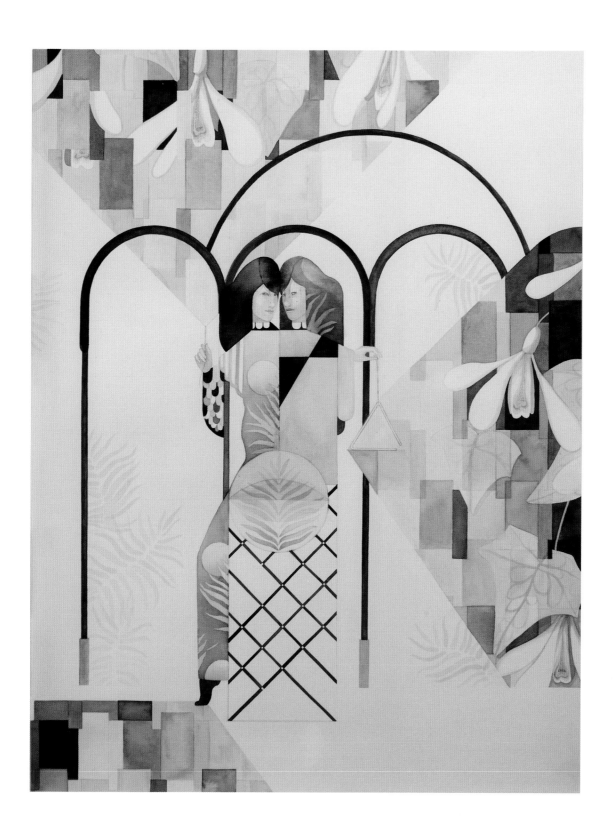

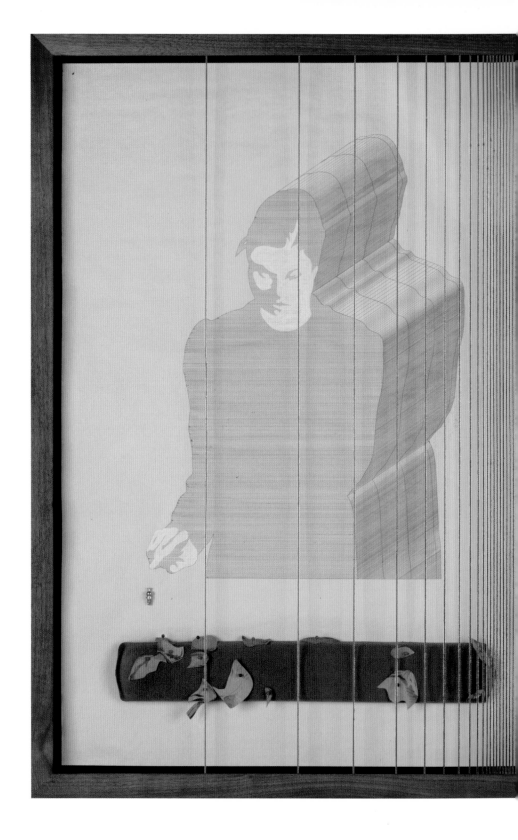

MARTIN WESTWOOD
(b. 1969, Sheffield)
Extrusion 24. Geld
2008

Working with mass-produced corporate objects, Martin Westwood constructs works that meditate on capitalist culture and personal freedoms. This is exemplified by *Extrusion 24. Geld*. The horizontals that construct the female form on the left, and the verticals layered across it, are strongly suggestive of office blinds, while the main dashes of colour throughout come from the scattered pink fragments on the desk and on the window form to the right. The relative sparseness of the scene, however, belies the painting's layered source material: the pink fragments are in fact cut-outs of muscles from DC comic books, while the word 'Geld' in the title refers to both the German word for money and the Old English word for castration. The cut-out pink biceps resemble the wings of dead biological specimens, while their counterparts to the right are enmeshed and ignored. With this reconfiguration of cultural symbols, Westwood subverts notions of male power, ambition, dominance and success.

STEVEN CLAYDON
(b. 1969, London)
Logs from the Black Forest
2007

Steven Claydon is an artist and musician whose installation
pieces comprise found objects, paintings and sculpture.
Logs from the Black Forest consists of a range of items,
including a blue office paper file and a hand from a
monumental sculpture, both mounted on plinths. These
plinths are bisected by the centerpiece of the work, a large,
three-panel office display board, painted with abstract
shapes and two grotesque semi-naked figures: a man
incised with geometric cuts and a clown-like figure, his loin
cloth the colour of the plastic file opposite. As in much of
his sculptural work, the piece plays with the juxtaposition
of the monumental and the banal: the folding office display
board mirrors the form of an altarpiece triptych; on their
plinths, the sculpted hand is afforded the same importance
as the paper file; the painted figures evoke both the
masters of surrealism and popular cartoons. For Claydon,
the pairing of these apparently contradictory elements
aims to explore 'the difference between the public face
of art and the private nature of it', particularly in relation
to the political character of the monumental sculpture,
which is invariably 'figurative' and 'patriarchal'. 'What I was
interested in doing,' he says, 'was to try and highlight this
by making a collision of elements within various props,
or a hybrid idea of a public monument by creating a fiction.'

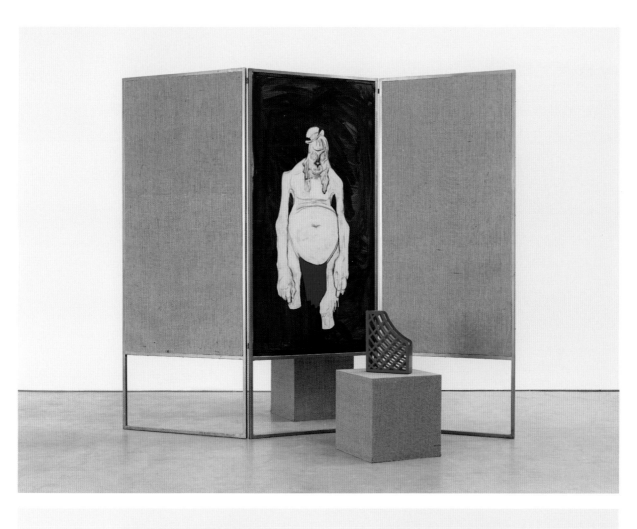

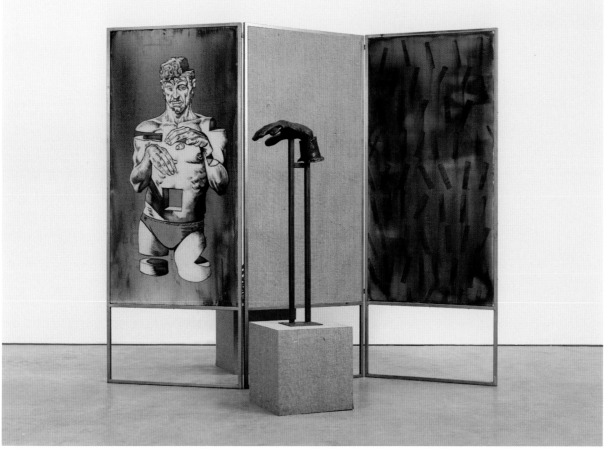

DAVID NOONAN
(b. 1969, Ballarat, Australia)
Untitled
2007

I studied painting and was a painter for quite a few years, so it's the foundation of how I think about making pictures. There are strong links in my work now to the art I was interested in at art school in Melbourne 25 years ago, but it's more about a kind of atmosphere rather than specific images. Music was important to me and, to some extent, it still is. I continue to think about painters such as Philip Guston and some of the German neo-expressionist painters from the 1980s and admire and follow painters from Australia too, such as Tony Clark, among others.

Apart from some works on paper, I stopped painting almost ten years ago now. My paintings always referenced photographs, either found images or, in some cases, scenarios that I had set up and then photographed. I then interpreted these scenarios in either paint or bleach on fabric. Making the bleach paintings was not unlike processing a photograph. I applied the bleach to very specific black fabrics and then 'exposed' the image onto the fabric in the way that you might expose a photograph on paper in a dark room. It was not a big leap for me to abandon this process altogether in order to work directly with photographic images themselves. I felt that by using a screen-printing process and photographic techniques, such as the overlaying of images, I was being more true to the original source material.

The techniques and methods I use now developed from the traditional language of painting. I print silkscreen images onto different linens each with its own tonal or textural quality; linen is traditionally used as a support for painting and not so associated with printmaking. The surface of the picture is important to me; I often collage elements of a number of prints together in order to construct the final image. Unlike the flatness that is usually associated with printmaking, the surface of my pictures is often

very active. I made the untitled picture now owned by the Arts
Council Collection in 2007 for a solo exhibition I had at the Palais
de Tokyo in Paris. I had been working with screen printing for several
years and it was around this time that I had started to think more
about scale. This piece is created from eight separate panels that come
together to form the final image. The shadow lines of the panels are
an important formal and graphic element to the work. It's like a double
exposure in a photograph or a film dissolve; images are frozen in a
moment so that one image is not privileged over the other, but their
combination forms two temporal moments simultaneously.

In this work, two images are overlaid over each other. One is of a
woman clasping her hand over her face; her hand is ceremoniously
wrapped in black twine, but we don't know why. She appears to
be in either a state of anxiety or a trance or like someone trying
desperately to remember something. The other image in the picture
is a group of seated figures gathered around a half naked woman
lying on a bare floor. The images are superimposed, so that you see
both simultaneously. A new scenario is formed between the different
elements: they are now inexplicably linked. This opens up narrative
possibilities that are denied to a single image, but it's important to me
that what this narrative means is open-ended and ambiguous. I am
interested not only in the formal elements within the picture – in how
aesthetically the two images come together – but also in how each
part of the image informs an atmospheric whole.

David Noonan

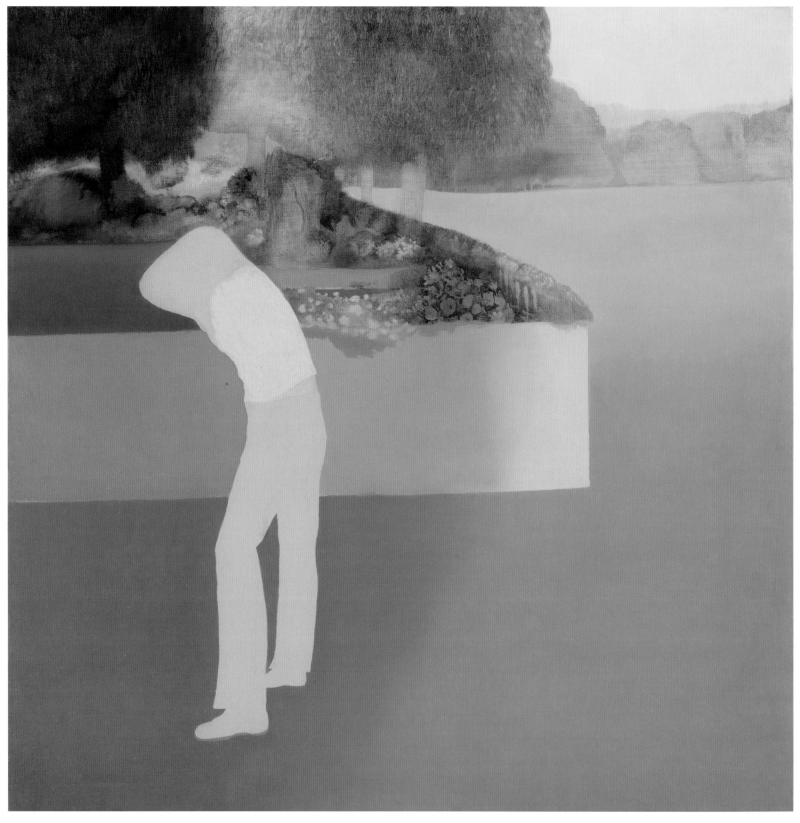

PETER UNSWORTH
(b. 1937, County Durham)
Still Garden
1965

Peter Unsworth's paintings employ pastel tones to
create soft, shadowy figures in landscapes imbued with
a dreamlike stillness. The atmosphere is often one of
tension or expectation, with figures placed alone in stage-
like landscapes; Unsworth worked for many years as a set
designer for the Royal Ballet Company. *Still Garden* is part
of a series of paintings focusing on the theme of cricket
and was first exhibited at the Piccadilly Gallery in London
in 1965. It takes its inspiration from T. S. Eliot's poem
'Burnt Norton', the first poem in the *Four Quartets*, which
is explicitly concerned with time as an abstract principle,
drawing on the imagery of a manor garden, after which the
poem was named. The painting explores Eliot's notion of
time, presenting it as a borderland between waking and
dreaming. The action of the isolated figure, set against
the lush green background, is unclear. The figure's frozen
pose might suggest that they are swinging a bat or catching
a ball, removing a jumper over their head or protecting
it from attack.

BARBARA WALKER
(b. 1964, Birmingham)
Boundary I
2000

Barbara Walker produces expressive paintings illustrating
social interactions in public spaces, from churches and
dancehalls to barbershops. Walker considers her work
to be social documentary and in her paintings consciously
aims to challenge what she sees as the misunderstandings
and stereotypes that abound about the African-Caribbean
community in Britain, offering instead a positive alternative
vision through her paintings. *Boundary I* is taken from
the series 'Private Face', which focused on the African-
Caribbean community of Birmingham. This painting draws
on the tradition of nineteenth-century realism and takes
inspiration from its depiction of the labouring classes of
the day. Walker's subject is a barbershop, a familiar sight
in the area of Handsworth in Birmingham where she grew
up. Using a limited palette of muted colours, *Boundary
I* reveals an intimate scene between a barber and client,
conveying a sense of mutual respect, trust and affection
between the two subjects. In doing so, the artist seeks to
dispel the negative portrayal of black males which dominate
the media.

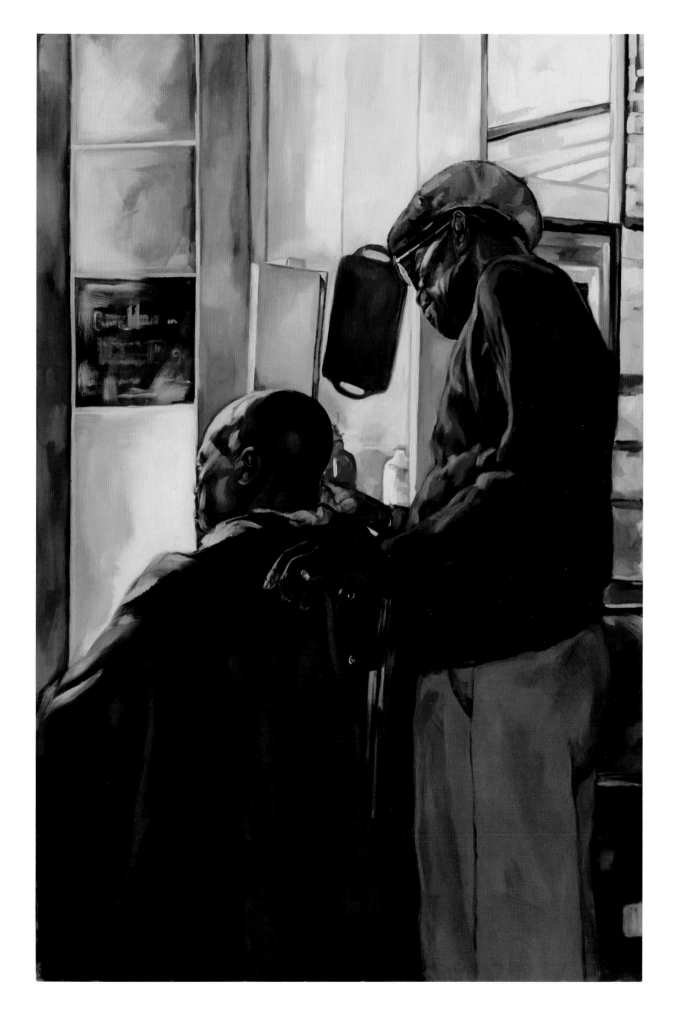

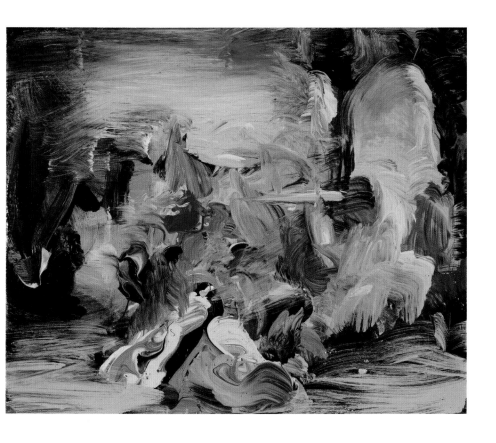

KATY MORAN
(b. 1975, Manchester)
Freddy's Friends
2006

Katy Moran's thick, gestural brushstrokes and creamy
colours hover between abstraction and suggestions of
figuration. She obtains her source images from the internet
by entering words into computer search engines, making
quick, intuitive selections and printing out numerous
copies of the selected images. The print-outs are then
turned upside down in order to further obscure the original
image and, using these as inspiration, she paints until
new figurative imagery begins to appear, enabling her
to discover 'the essence of the colour and contrasts' that
initially interested her. As she notes: 'I often disrupt the act
of painting to introduce chance elements and intensify the
already unpredictable behaviour of the fluid medium.' The
title of this work is a reference to a first birthday party which
Moran had attended for a friend's son called Freddy. She
recalled that the house, which was full of babies, toys and
colour, had a 'fairytale quality', which she aimed to reflect
in her painting.

ROY GRAYSON
(b. 1936, Sheffield)
The Blind Poet in Pursuit of the Muse of Fashion
1983

The notion of the artist as poet is a theme that Roy Grayson
has returned to throughout his career, but first addressed
in 1983 with the series of works entitled 'Against Nature,
Pictures Devised for the Composers of Obscure Poetry'.
Grayson sets out to demonstrate that the essence of art
is cerebral, not visual, and that its expression can take
almost any form. Reflecting on this proposition, he states
that 'the impulsion of the text is clearly ex-centric, moving
between surfaces. It is a practice, not a theory; the writer
and the painter do not begin with something to express, nor
do they seek to impose form on chaos, nor do they merely
receive impressions. They take up position.' The series drew
inspiration from the French writer J. K. Huysmans' novel,
Against Nature (1884), which is widely viewed as a definitive
example of decadent literature. Consisting of six works
completed between 1983 and 1984, including *The Blind
Poet in Pursuit of the Muse of Fashion*, Grayson employs
his highly coded approach to painting to invoke the esoteric
aesthetic of Huysmans' hero Jean des Esseintes, using a
fragment of text taken from Chapter XIV of *Against Nature*
at the bottom of each canvas.

LACUNAE OF IMPEDIMENTS

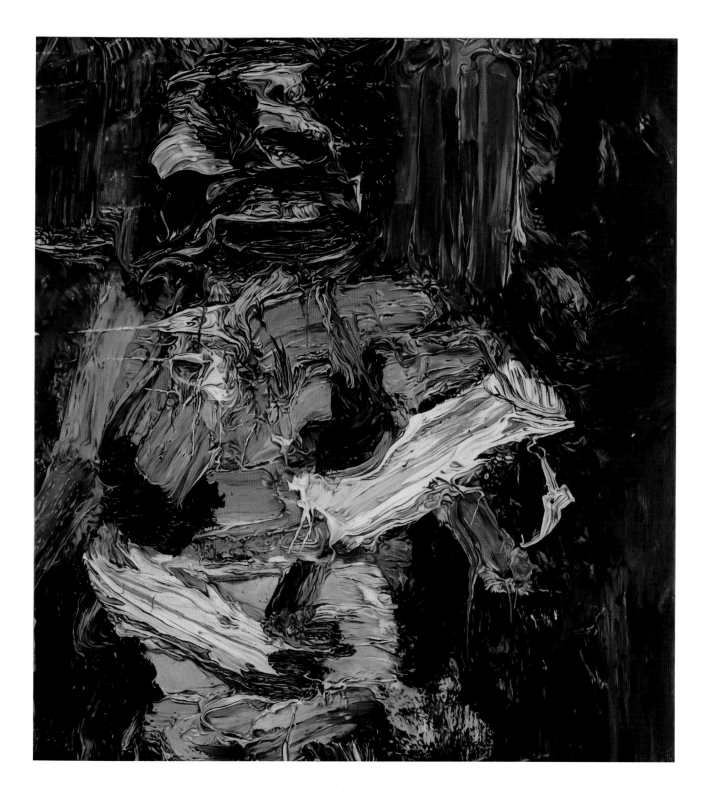

GLENN BROWN
(b. 1966, Hexham, Northumberland)
Decline and Fall
1995

Like a number of my paintings in the 1990s, *Decline and Fall* (1995)
is based on a detail of a painting by Frank Auerbach of J.Y.M.
(Juliet Yardley Mills, who the artist painted over 70 times), but
in my work, Auerbach's thick impasto brush-marks are rendered
perfectly flat and photorealist. The overriding mood of the 1990s
was that 'painting is dead'; conceptual art and photography had
killed it. I – like many fellow artists – had been impressed by the
ways in which Sigmar Polke and Gerhard Richter's painted pop
had hit photography head-on. If painting was, in fact, dead then
what better place for a young artist brought up on the isolated
flatlands of Norfolk with a liking for gothic horror to be than in its
morgue? Pulling out books from a library shelf was like pulling out
the recorded lives of the irrelevant, the ignored and the deceased.
Auerbach's paintings seemed to have a ready atmosphere of the
graveyard. My slowly painted detail encapsulates the flesh of the
figure like a painstaking autopsy.

It was important to me that the painting was figurative. I had
made similar paintings that were more abstract but – without the
notion that a real living and breathing figure had once existed and
been immortalised in paint – the idea of representing death seemed
less close. I wanted the figure to breathe down the back of your
neck, to be – although not exactly alive – always present. J.Y.M. has
been buried by successive layers of representation. First painted,
then photographed, then printed in a book, then painted again, and
now, no doubt, photographed and printed once again in the pages
of this book.

My title, *Decline and Fall*, obviously refers to Edward Gibbon's
The History of the Decline and Fall of the Roman Empire (1776–88).
Complete changes of scale interest me. Relating the life of a whole
empire to that of one individual is an absurdity meant to highlight
one's existentialist isolation. Physical and mental decline following
a fall is a fear that becomes increasingly present as we age.

With this merciless conceptual form of painting there was little
need for sketches. I took some time working out where to crop
the image to achieve a slightly awkward, unbalanced feel. I also
heightened the colours to add to the paintings putrefied sensibility.

Of course, it turned out that painting was not so dead after all
and I became bored with the limits of photorealism soon after
this painting dried. There was so much more to look forward to
when making a painting, and so many more ways to entice the eye
than mere copying. I do, however, find its directness of intent an
interesting statement, and I am still intrigued that I made it.

Glenn Brown

BOB ROBINSON
(b. 1951, Newtownstewart, County Tyrone)
A Preference for Crisps
1979

Bob Robinson came to painting late in life: he first visited
a gallery in his twenties and only later decided to pursue
a career as an artist following a conversation with his
landlord. Robinson's paintings reflect his interest in the
tensions of domestic life and everyday dramas portrayed
in images that suggest an implicit narrative. In works like
A Preference for Crisps, Robinson drew on a range of
familiar domestic imagery from his own home, including
mail order catalogues, car showroom brochures and
wallpaper sample books, to create his skewed vernacular
scenes. The narrative in this early work is centred around
an everyday situation: two friends having a meal in a cafe.
The subject of the painting has abandoned his meal in
favour of a packet of crisps and is ignoring his companion's
offer of a cigarette as he is distracted by the activity within
the cafe. The composition of the painting, with its clearly
delineated graphic patterns and flattened perspective,
is typical of Robinson's style during this early stage of
his career.

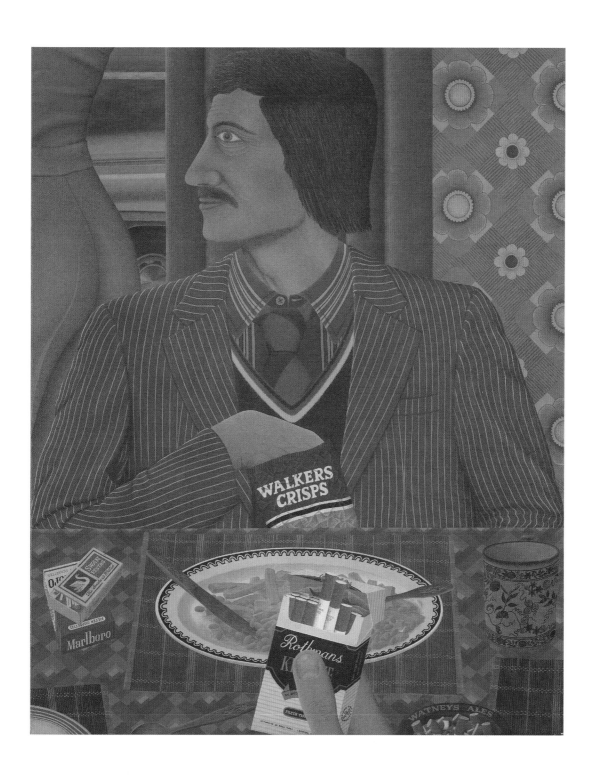

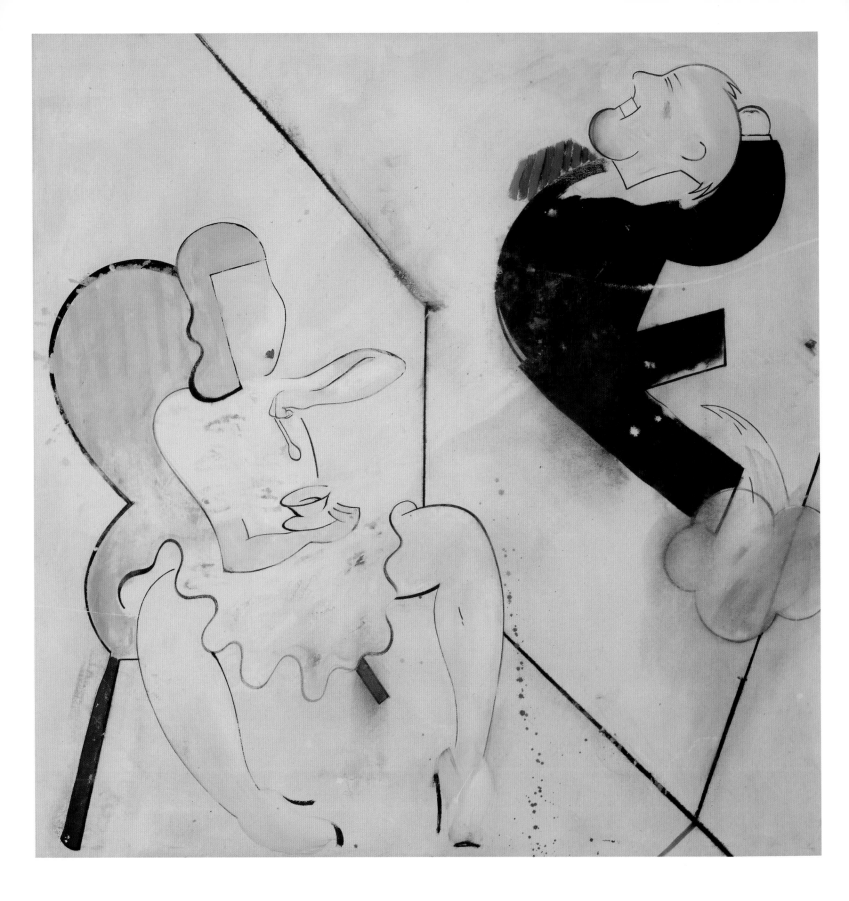

JOCK McFADYEN
(b. 1950, Paisley)
Those heady days seemed to last forever, Siegfried
jumping around like the big idiot he was
1978

Jock McFadyen's early work has been described as a mixture of the expressive and the caricature. His desire to portray everyday human experiences in a direct and expressive manner was partly nurtured by ceaseless doodling during his youth. His early work shows the influence of David Hockney in its borrowing of cartoon imagery reworked with playful references to art history. *Those heady days seemed to last for ever...* was made at a time when McFadyen was preoccupied with the act of making paintings that illustrated a random piece of text culled from the mass media. These snippets were often glib or ludicrous and at other times political or bleak, describing the process as 'making irony' by 'pimping' text and imagery. His ambition was to exhibit works from this period cheek-by-jowl, creating juxtapositions that mirrored the average newspaper or television news broadcast, which might feature stories covering famine or war alongside light human-interest pieces.

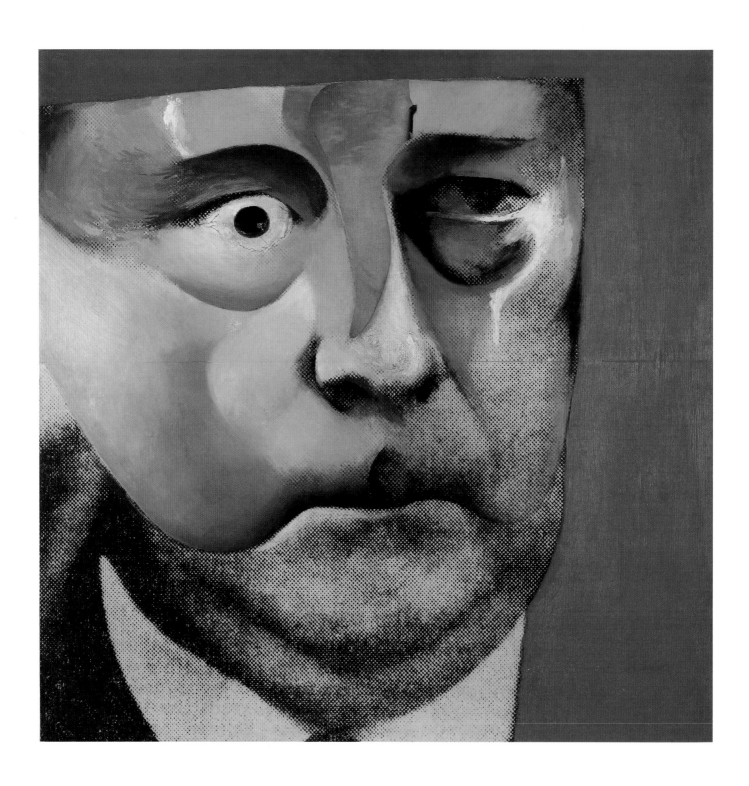

RICHARD HAMILTON
(b. 1922, London; d. 2011, London)
*Portrait of Hugh Gaitskell as a Famous
Monster of Filmland*
1964

One of the most influential British artists of the twentieth century, Richard Hamilton's varied work encompasses both pioneering pop art collages and highly political subject matter. This portrait of Hugh Gaitskell (1906–63) is one of his well-known satirical works. Gaitskell was Leader of the Labour Party in opposition for seven years and was regarded by Hamilton as a 'political monster' due to his vacillation over forming a clear anti-nuclear policy. In this work, an enlarged newspaper photograph of Gaitskell has been fused with a fictional monster derived from a *Famous Monsters of Filmland* magazine cover of the actor Claude Rains in make-up for the 1943 film of *The Phantom of the Opera*. Hamilton also sourced other horror film images for the painting: the head, cut off above the eyebrows, is a reference to a film-still of a man-monster from *The Creature with the Atom Brain* (1955), while the bloodshot eyeball derives from a 1959 film of *Jack the Ripper*. An advocate of nuclear disarmament, Hamilton regarded this painting as a tribute to his first wife, Terry, an ardent CND activist, who died in a car accident in 1962.

LIZ ARNOLD
(b. 1964, Perth; d. 2001, London)
Uncovered
1995

Despite the innate humour in the work of Liz Arnold,
she did not consider her work to be in any way sardonic:
'There's an assumption that if you work with paint you have
to be ironic or cool, or in some way apologetic about it, but
I don't feel like that.' The subjects of her paintings, inspired
by film, cartoons and computer games, were part of a
sincere attempt to expand the subject matter of painting.
As she saw it, the flat surfaces and anthropomorphic figures
in her paintings were 'all very acceptable in the world of
the cartoon or on a computer screen but when you do it in
a painting people say: "Oh my God". [...] People are quite
conservative about what they can and can't accept in a
painting.' *Uncovered* depicts a cartoonish, winged insect
wearing a transparent bra and knickers, standing between
three discarded bones and a dusky industrial landscape.
The figure is characteristic of the creatures that populate
Arnold's work, placed in a setting that encourages the viewer
to try and create a narrative around the image. Arnold
called the figure 'Secret Agent Greenfly – an eco-detective
posing as a beach-holiday-maker' who is 'a femme fatale
– finely furry all over except her shaved legs'. In Arnold's
words, 'the narrative is open', but there is a 'suggestion of
film noir-ish dangerous female sexuality'.

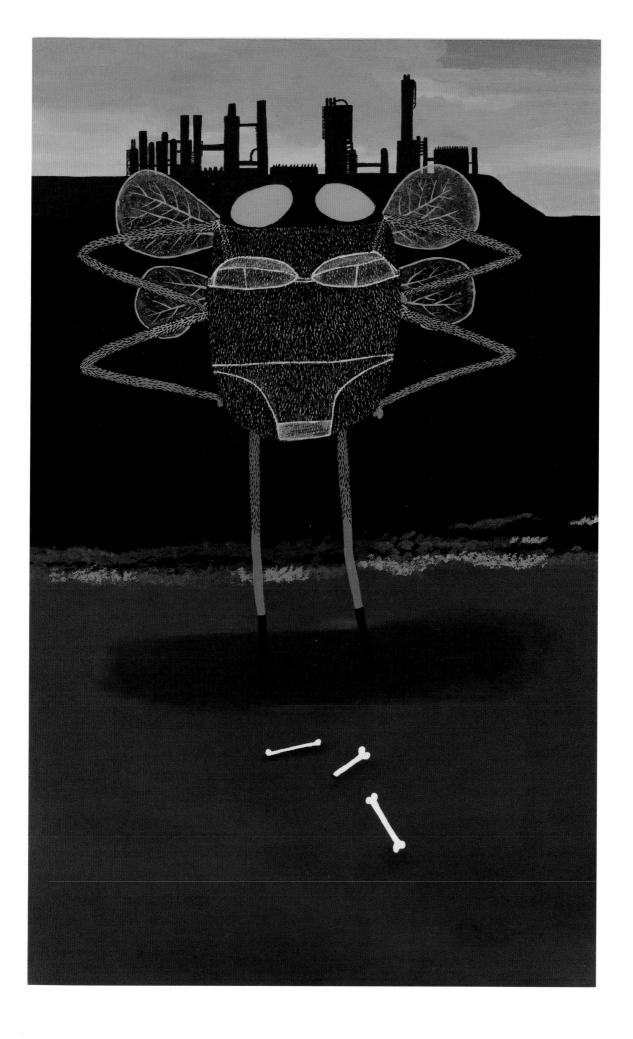

EUAN UGLOW
(b. 1932, London; d. 2000, London)
Girl's Head in Profile with Cap On
1963–64

All of Euan Uglow's paintings developed from an intense scrutiny of his chosen subject matter, frequently taking months, and even years, to reach completion. He used the small measuring marks seen here to record forms, commenting that 'they are to do with what happened today, yesterday and the month before. It's a chart or diary of what happened, while still trying to keep to the idea of what the painting is.' In *Girl's Head in Profile with Cap On*, every detail, from the hairstyle to the folds of drapery, is painstakingly considered and precisely placed by the artist: the blue and white panels of the cap guide our eyes to appreciate the contours and ovoid shape of her head, with its broadness on the crown and striking profile. Uglow did not undertake commissioned portraits, preferring to use models, but noted: 'I paint heads, but I never think of getting it to look like anybody.'

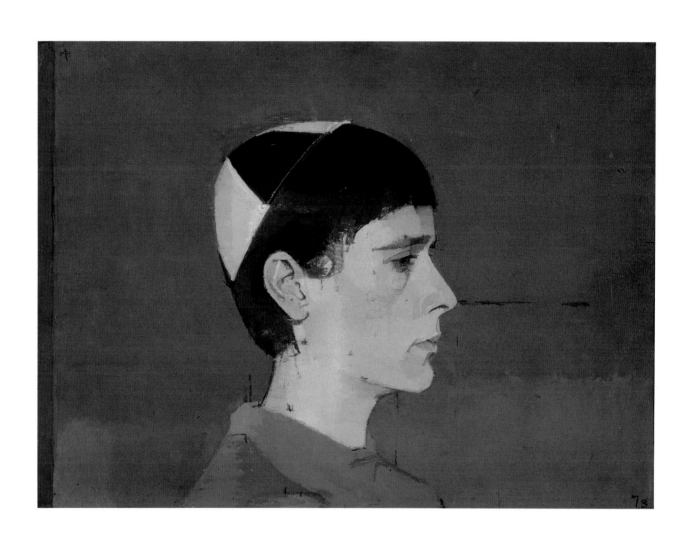

73

Why do I paint figuratively? Because it is easier to tell a story figuratively than with lines and blobs: I can only tell a story that way.

I don't remember the evolution of my painting *Sleeping* (1986); it simply grew from the one I did before it. The girls have been working in the fields and are taking a rest. It's sort of a religious picture: the bird is a symbol of Christianity. The original pelican story had a mother pelican feeding her young with her blood and later it became a symbol of Christ.

I often do preparatory sketches to work out the composition so as to tell the story in the best way possible, although some things pop up unexpectedly. Very often I discover the personal element of the picture only after I've made it.

I have been influenced by everything that Francisco de Goya created, but particularly his prints, the black paintings and his studies for tapestries. I have also been influenced by Gustave Doré's illustrations for Dante's *Inferno*, which are frightening and curious, Jean Dubuffet for the childlike freedom of his paintings, and I adore James Ensor, especially for the grotesque element in his pictures. I have pretty much been influenced by most paintings at the Prado in Madrid: it's the best museum in the world.

Paula Rego

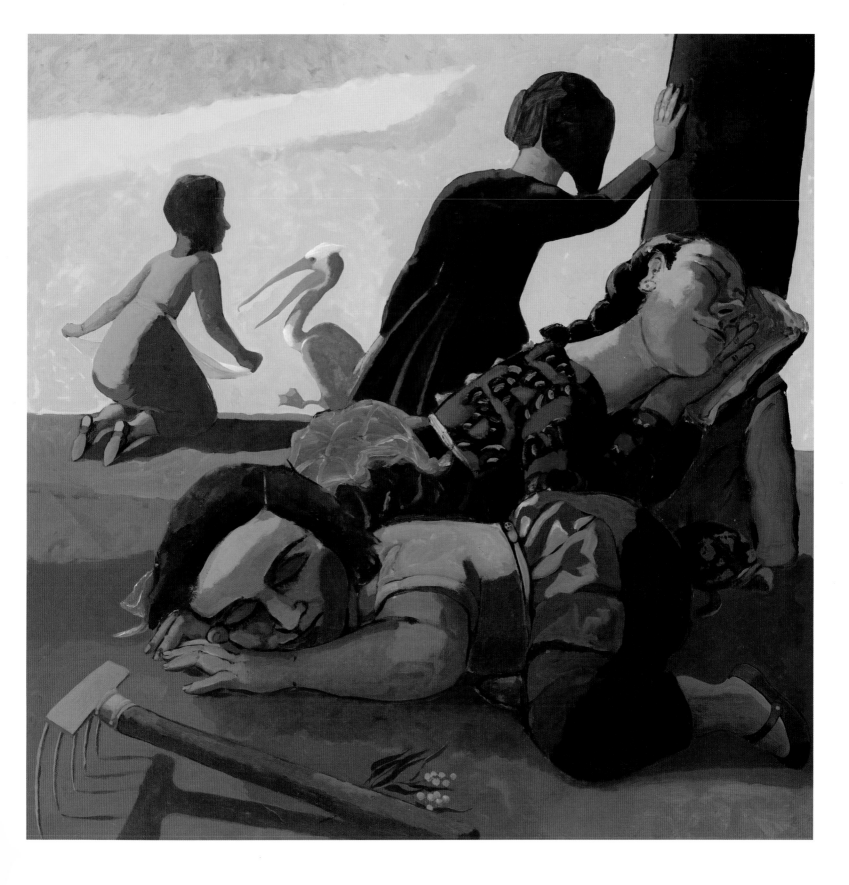

PAULA REGO
(b. 1935, Lisbon)
Sleeping
1986

EILEEN AGAR
(b. 1899, Buenos Aires; d. 1991, London)
Poet and his Muse
1959

'Paris was *the* place for any artist to be in the 1920s' wrote Eileen Agar, and it was there that she met many of the leading creative personalities of the day, including Picasso and the surrealist poet Paul Eluard. These relationships had a profound influence on her work and in *Poet and his Muse*, there are clear echoes of the expressive distortions of Picasso and the overlapping planes of cubism. The subject of the artist and their muse is an established one and has traditionally been presented as a serene encounter. Agar's version, however, conveys a very modern sensibility, implying the sources of artistic inspiration are exotic, intoxicating and frenzied. Agar's second husband was the Hungarian writer Joseph Bard (1872–1975) and he is thought to be the inspiration behind many of her works.

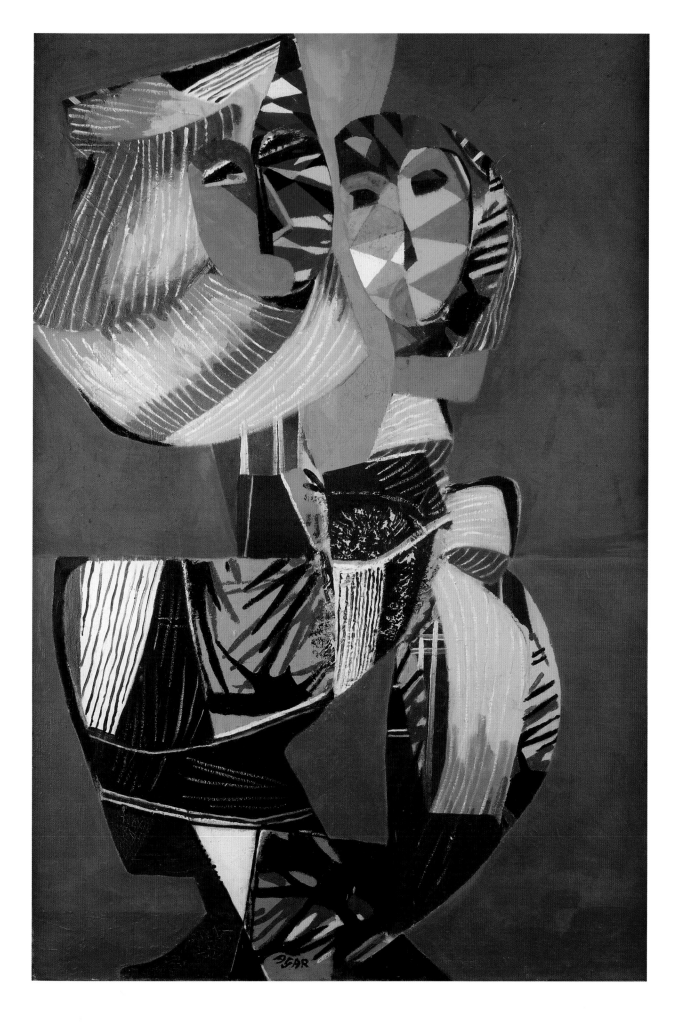

CERI RICHARDS
(b. 1903, Swansea; d. 1971, London)
Two Musicians
c. 1954

Ceri Richards had a passion for music and poetry befitting his Welsh roots and both of these art forms provided the inspiration for many of his paintings. During the late 1940s and early 1950s, Richards made a series of paintings of pianists in interiors. Although the figures are generic rather than portraits of particular people, his muse was often his younger sister Esther, who was a good pianist and played for many years as accompanist to the Dunvant Male Voice Choir. Dunvant, a small mining village to the west of Swansea, was Richards' birthplace and his early years there, steeped in music and literature, made a significant impact on his art. Richards was himself a gifted pianist and had a particular passion for the work of Beethoven and Debussy. In *Two Musicians*, the lively arabesques of the violinist's body suggest the rhythm and flow of the music being played, while there is a reflective stillness about the pianist, who has turned to listen to her companion. These arabesques are mirrored in the dragon pattern on the pot, which is placed centrally behind the two figures. Owned and decorated by Richards himself, it appears in a number of his paintings.

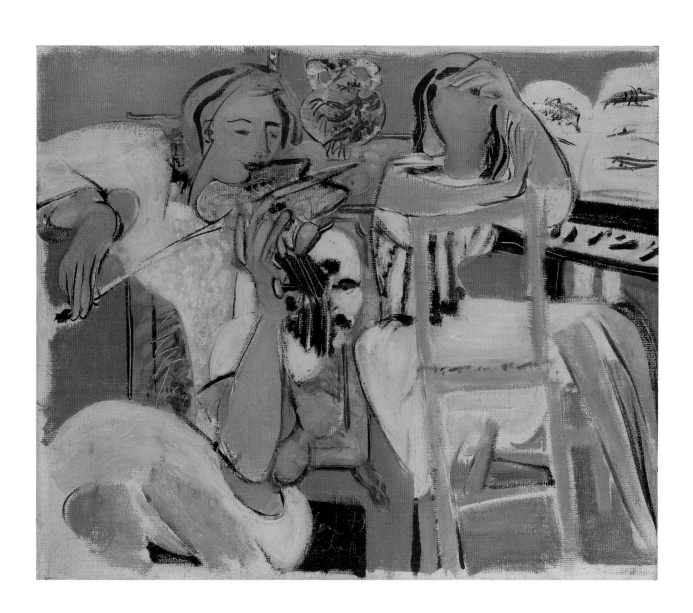

ENRICO DAVID
(b. 1966, Ancona, Italy)
Untitled (puppets: we are the mods)
2003

Enrico David is a multidisciplinary artist, whose work
includes film and live performance, but also handcrafted
objects. In the past, many of his works were produced
collaboratively with other artists, often taking the form
of staged, theatrical performances – themes that are also
evident in his sculptural work. *Untitled (puppets: we are
the mods)* was, as the artist has stated, 'created in 2003 as
the potential subject of a video animation to a musical score
by Mark Leckey. Based on an earlier piece of sculpture
(Untitled subjects, 2001), we filmed the puppets on stage
of a nightclub with each figure manoeuvred by the members
of the music collective donAteller, a "real" band including
Mark Leckey, Bonnie Camplin, Ed-Laliq, Nick Relph and
myself.' David had planned to film the puppets in the
sculpture bursting into flames, but the video was never
completed, and were used instead to create this sculptural
piece, reminiscent of the box works of Joseph Cornell.

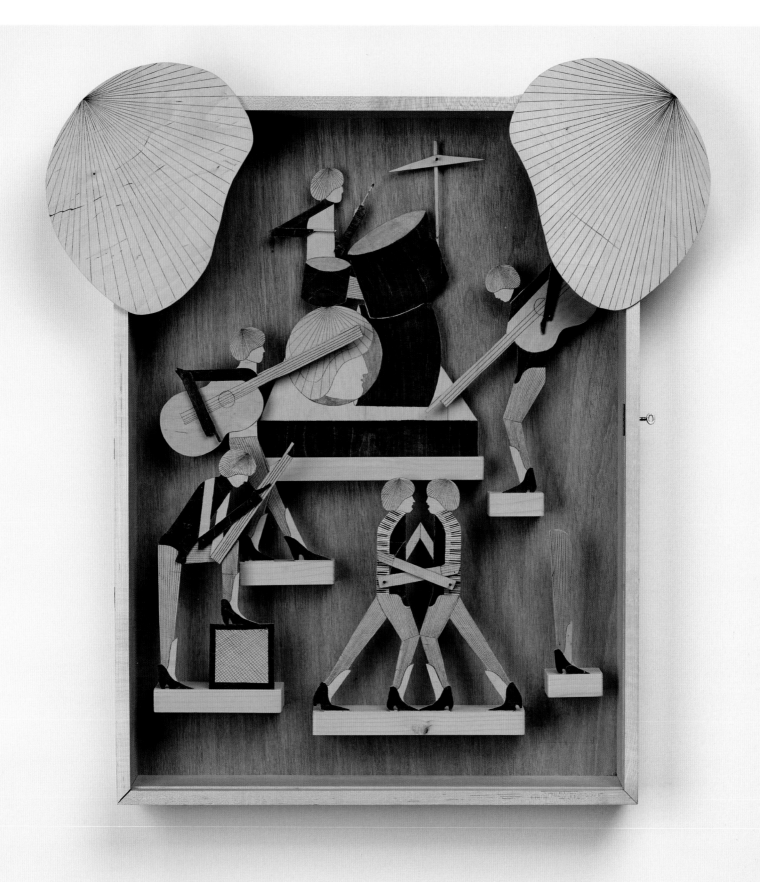

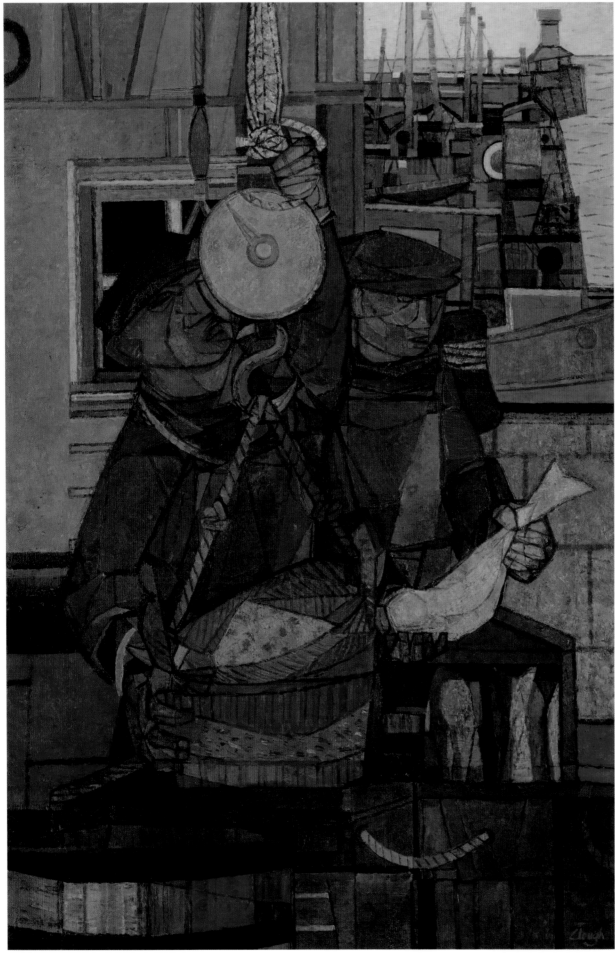

PRUNELLA CLOUGH
(b. 1919, London; d. 1999, London)
Lowestoft Harbour
1951

Prunella Clough, noted for the delicate balance between figuration and abstraction in her pictures, summed up her approach to painting by saying, 'I am essentially an "eye" person, totally affected by visual fact.' *Lowestoft Harbour*, an early work, shows a contemporary scene of dockside workers weighing and packing fish. The figures have been visually integrated into their surroundings, however, the grey and brown lines around the edges suggest the development of her later abstractions. It was painted as the result of an invitation by the Arts Council to take part in their Festival of Britain touring exhibition, *60 Paintings for '51*, from which it was then purchased for the Arts Council Collection. Clough had spent time in East Anglia during the war years and continued to visit the area to paint the fishing ports at Lowestoft and Southwold with their busy maritime life, often focusing on closely observed details of ropes, barrels and machinery. In keeping with much painting made in post-war Britain, its colour is subdued, but perhaps the tones have more to do with Clough's observation that the English weather meant 'the things that I see tend to be somewhat murky'. She later turned to the docklands of the Thames estuary and the surrounding industrial landscapes as subjects for her works, which, although always informed by observation, became increasingly abstract.

ALFRED WOLMARK
(b. 1877, Warsaw; d. 1961, London)
Woman with a Bowl of Fruit
1913

Alfred Wolmark was a painter and designer of pottery and
stained glass. Having moved to England from Poland,
aged six, he went on to study at the Royal Academy Schools
and became one of the pioneers of post-impressionism
in England. His early figurative work depicted scenes of
Jewish life in East London. In 1910, however, there was
a dramatic change of direction in his painting as he began
producing expressive works similar in style to those of Van
Gogh and Gauguin. Their work had been included in Roger
Fry's famous post-impressionist exhibition in London in
November 1910, the first of its kind in Britain, although it is
not known if Wolmark was aware of the exhibition or the two
artists at this time. Wolmark remained independent of the
many avant-garde movements of the day, believing instead
in his own creed that 'the basis of painting must primarily
be form and colour' and stating that his ambition was to 'fill
great wall spaces with mosaics of glowing colour that speak
to the mind like inspired music.' *Woman with a Bowl of
Fruit*, with its flattened, stylised design and vivid colour,
is typical of his work during this period.

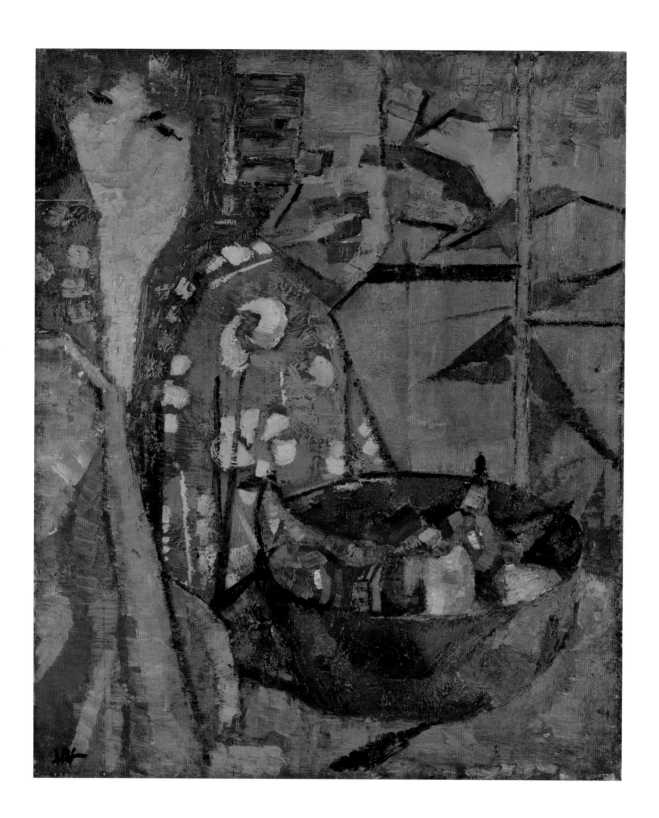

MALCOLM DRUMMOND
(b. 1880, Boyne Hill, Berkshire; d. 1945, Moulsford,
Oxfordshire)
Brompton Oratory
c. 1912

A founding member of both the London Group and the
Camden Town Group, Drummond painted scenes of
everyday life and domestic interiors in London. Similar
to his friend and teacher Walter Sickert, Drummond made
complex preparatory drawings for his paintings; an early
sketch of *Brompton Oratory* is also held in the Arts Council
Collection. The Brompton Oratory is a large neo-classical
Roman Catholic church located in South Kensington,
London, near to where the artist lived and worked at the
time, and was painted shortly after the artist's conversion
to Catholicism. Aside from reflecting his newly confirmed
faith, the painting's subject also addresses a theme
common to a number of the artists in the Camden Town
Group: the public consumption of music, be it in a church,
a salon or music hall. The framing of Drummond's image
is particularly striking: an unusually narrow canvas and
a composition that emphasises the architectural forms
of the church, particularly the large column at the centre,
rather than the congregation huddled below. The tight
cropping reflects both Drummond's interest in the shapes
and patterns of buildings, as evidenced in the preparatory
sketch for the work, but also the influence of photographic
composition on Drummond and his contemporaries.

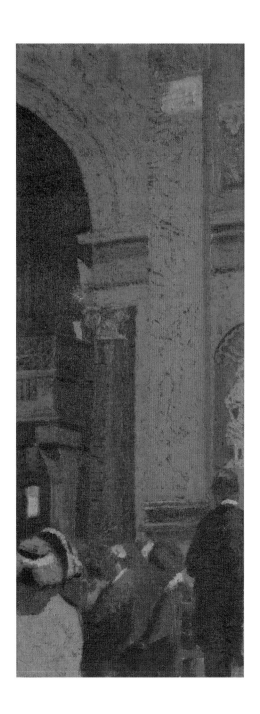

ROSE WYLIE
(b. 1934, Hythe)
Girl on Liner
1996

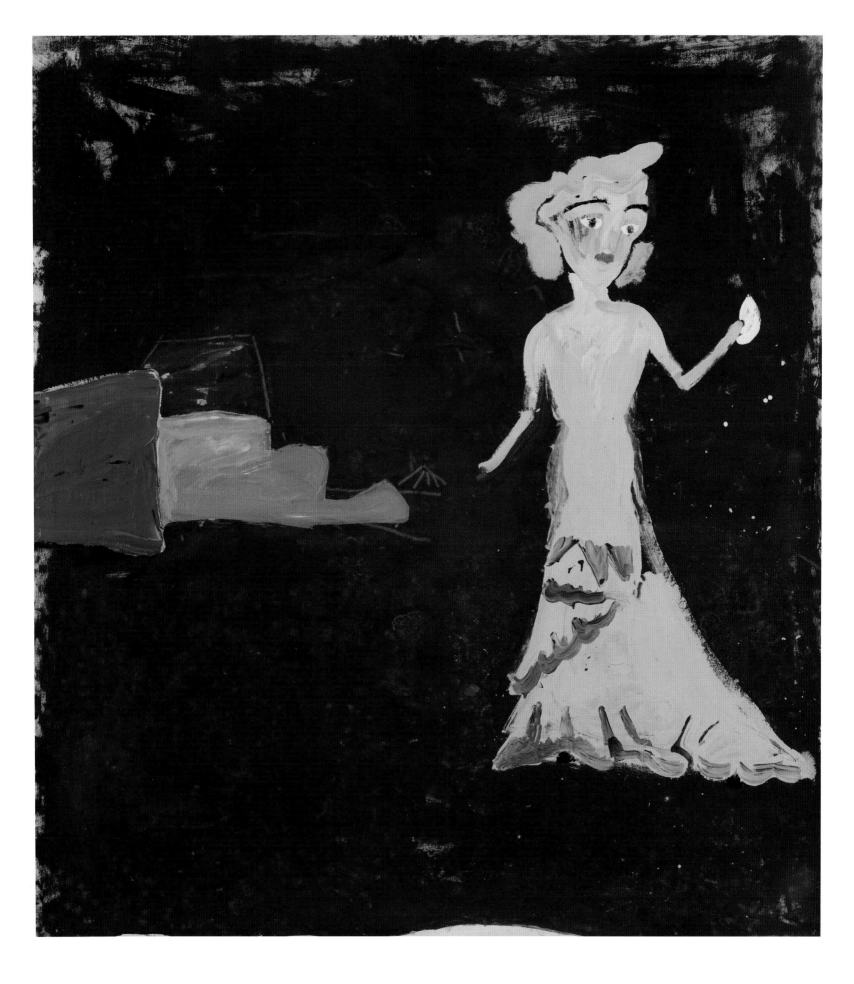

I paint figuratively as I think it's more interesting both to do and to look at. I like the specifics of the real world (and the visually relational), which does not mean I go for copying it; I like being specific in a painting. Henri Matisse once said that when you're drawing you should 'bring in everything at your disposal'. He advises 'synthesis' not 'analysis'. The speed, the sparkle, the thought bubbles and the helpful writing of cartoon language is good at this.

With abstract art, no one can see quite what you're bringing in, as it's not clear where you start from, especially without a text. Figuration pulls in more possibilities, more either/ors, more anxious decision-making, except, that is, for Kazimir Malevich who 'aced' for abstract. Abstraction, rather than abstract, is OK with me, as it's always been there –it's a key metaphor in the process of transformation. I think that the business of transformation in painting is central, but at the same time you need to keep hold of the objective image of things that everybody knows. In abstract art, that's not its business, and so perhaps it's less vulnerable, and it can't go wrong as easily; it is not so risky.

It's hard to make an image which is wonderful while hanging on to some sort of realism – Henri Rousseau does it and it's why Matisse's 1919 painting *Tea* is so good; there is no distortion, or even abstraction in it, but its transformative connection to what we know prevents it from becoming in the least bit dull or meaningless. To distort or not, or how much, or in what way are the central questions in figurative painting. Can you distort an abstract painting?

My painting *Girl on a Liner* (1996) was the result of a small ad I saw in a newspaper about the glamour of sea travel. I think the girl was gliding towards the captain's table. The whole ad, including the graphics, was very naff, which is probably why I liked it and used it. In my painting, the Georgian house and hedge behind the girl substituted for the liner, while I stuck with her evening gear, her gloves and her yellow hair.

After my preliminary drawings, the painting began with a lengthy 'tread-in' of alizarin crimson – I wanted a soft saturation of colour and the feel of distressed canvas on which to balance the pink skin colour, pale blue and yellow, which I hoped bounced-off.

I used my feet to tread-in the paint, into and through the canvas – it must have been summer, as I used to work without shoes until I was told that 'thinner' in the toenails was not a good idea. The well-defined curving line at the bottom of the painting was done with a brush to separate the tread-in from the original canvas, and push it further back, or bring it forward.

When the Arts Council Collection chose this painting, I was very pleased – I'm not sure they knew it was partly a 'foot' painting, as I probably didn't mention it. There is only one other painting that I made in the same 'trodden way': they were both, as were all of my paintings at the time, painted on the floor, which I used to prefer as an alternative to an easel or wall as it gave me a lot more room to work with.

In terms of influence: I've spent a lot of time looking at Paul Cézanne's early work, before he intellectualised it and cut out all of his shadows and passion. Walt Disney's *Snow White and the Seven Dwarfs* (1937) made a great impression on me at the age of four, as did Jean de Brunhoff's illustrations for the 'Babar the Elephant' books. I've also borrowed cross-hatching and the 'aura' from Italian Renaissance painting; a language for defining volume from Albrecht Dürer's early simplified woodcuts, and I first met something 'naff' in an El Greco painting. All of the old painters are so good; I never know quite why that is.

Rose Wylie

LUCIAN FREUD
(b. 1922, Berlin; d. 2011, London)
Girl in a Green Dress
1954

Girl in a Green Dress is an exceptional example of Lucian Freud's meticulously analytic early paintings of single figures, with each freckle, vein and eyelash precisely recorded with a fine sable brush. Caroline Blackwell (1931–96), the subject of this painting, was Freud's second wife. As he wrote: 'My work is purely autobiographical. It is about myself and my surroundings. I work from the people that interest me, and that I care about and think about, in rooms that I live in and know, I use the people to invent my pictures with, and I can work more freely when they are there.' Freud and Blackwell married in 1953 and she sat for him several times during the early 1950s, including for the painting *Hotel Bedroom* (1954) which shows Freud in the shadows gazing down at Blackwell resting in bed. As with the other portraits of Blackwell, it shows both tenderness and a despondent anxiety. Freud and Blackwell's marriage was short-lived and they divorced in 1957. Blackwell, a novelist and heiress from the Guinness family, went on to marry the composer Israel Citkowitz and later the American poet Robert Lowell.

List of Works

All works are courtesy Arts Council Collection, Southbank Centre, London, unless otherwise stated. All measurements are in centimetres and are width x height x depth

Eileen Agar
Poet and his Muse
1959
Oil on canvas
91.5 x 60.7

Michael Andrews
Study of a Head for a Group of Figures No. 10
1968
Oil on board
31.6 x 16.5

Liz Arnold
Uncovered
1995
Acrylic on canvas
122.5 x 76.2
Gift of Charles Saatchi

Walter Bayes
Box at the Lyceum Theatre
c. 1932
Oil on canvas
53.3 x 45.7

Peter Blake
Boy Eating a Hot Dog
1960–65
Acrylic on board
36.5 x 40.7

Glenn Brown
Decline and Fall
1995
Oil and canvas on board
58.4 x 54.6

Jeffery Camp
Laetitia Picking Blackcurrants
1967
Oil and alkyd resin on board
61 diameter

Steven Claydon
Logs from the Black Forest
2007
Oil on canvas, steel, bakram, wood, bronze and plaster
Five parts:
199 x 81
145 x 40.5 x 40.5
18.6 x 40.5 x 23.5
30.4 x 23.4 x 6.6
40.5 x 40.5 x 40.5

Prunella Clough
Lowestoft Harbour
1951
Oil on canvas
162.6 x 106.7

Robert Colquhoun
Seated Woman and Cat
1946
Oil on canvas
97 x 76

Enrico David
Untitled (puppets: we are the mods)
2003
Glass and wood
85 x 65 x 12

Milena Dragicevic
Supplicant 101
2008
Oil on linen
61 x 51

Malcolm Drummond
Brompton Oratory
c. 1912
Oil on canvas
53.3 x 20.3

Lucian Freud
Girl in a Green Dress
1954
Oil on board
32.5 x 23.6

Michael Fullerton
Katharine Graham
2008
Oil on linen
61 x 46

Alasdair Gray
Juliet in Red Trousers
1976
Oil on paper, mounted on wood
99 x 49.5

Roy Grayson
The Blind Poet in Pursuit of the Muse of Fashion
1983
Oil and collage on linen
135 x 114

Richard Hamilton
Portrait of Hugh Gaitskell as a Famous Monster of Filmland
1964
Oil and collage on photograph on panel
61 x 61

Georgia Hayes
SAVED BY DROWNING (SICILIAN FOUNTAIN 2)
2013
Oil on canvas
183 x 183

David Hockney
Portrait Surrounded by Artistic Devices
1965
Acrylic on canvas
152.4 x 182.9

Donna Huddleston
Untitled
2010
Watercolour, pencil and gouache on paper
70 x 55

Jock McFadyen
Those heady days seemed to last forever, Siegfried jumping around like the big idiot he was
1978
Oil on canvas
122.8 x 121.8

Katy Moran
Freddy's Friends
2006
Acrylic on canvas
Three parts, total 46 x 117.2

Ryan Mosley
Northern Ritual
2011
Oil on canvas
230 x 195

David Noonan
Untitled
2007
Silkscreen on linen
213.5 x 306 x 4.5

Paula Rego
Sleeping
1986
Acrylic on canvas
149.8 x 149.5
With financial assistance from
English Estates

Ceri Richards
Two Musicians
c. 1954
Oil on canvas
51 x 61
Bequest of Sir William Emrys
and Lady Williams

William Roberts
The Seaside
c. 1966
Oil on canvas
61 x 76.2

Bob Robinson
A Preference for Crisps
1979
Acrylic on canvas
76 x 61

Walter Sickert
Head of a Woman
1906
Oil on canvas
49.3 x 39.3

Renee So
Drunken Bellarmine
2012
Wool, acrylic, oak, tray frame
174 x 124

Euan Uglow
Girl's Head in Profile with Cap On
1963–64
Oil on board
40 x 55.9

Peter Unsworth
Still Garden
1965
Oil on canvas
76.2 x 76.2

Phoebe Unwin
Sleeper
2012
Oil on linen
50 x 76

Barbara Walker
Boundary I
2000
Oil on canvas
182 x 121

Martin Westwood
Extrusion 24. Geld
2008
Paper, newsprint, rubber, vinyl,
gouache, metal and pen on board
97 x 140.1 x 7.2

Alfred Wolmark
Woman with a Bowl of Fruit
1913
Oil on canvas
61 x 50.8

Rose Wylie
Girl on Liner
1996
Oil on canvas
183 x 163

Lynette Yiadom-Boakye
Condor and the Mole
2011
Oil on canvas
230 x 250

All images are copyright the artist
2014 unless otherwise stated:

© Peter Blake. All rights
reserved, DACS 2014, p. 22;
© R. Hamilton. All Rights
Reserved, DACS 2014, p. 76;
© Estate of Ceri Richards.
All rights reserved, DACS 2014,
p. 87; © The Lucian Freud
Archive/Bridgeman Images,
p. 100; © Estate of Walter Bayes,
p. 21; © Estate of Malcolm
Drummond, p. 95; © Estate
of Eileen Agar, p. 85; © Estate
of Robert Colquhoun/Arts
Council Collection, Southbank
Centre, London, UK/Bridgeman
Images, p. 39; © Peter Unsworth
2014, p. 60; © Estate of Alfred
Wolmark, p. 92

Short artists texts written by:

Catherine Antoni (pp. 30, 61, 62,
66, 75, 92), Steven Burridge
(pp. 20, 72, 94), Catherine Gaffney
(pp. 18, 24, 26, 33, 36, 48, 50, 53,
88), Ben Fergusson (pp. 38, 43,
44, 54, 79), Ann Jones (pp. 35, 47,
65, 77, 80, 84, 86, 91, 101) and
Natalie Rudd (p. 23)

Published on the occasion
of the exhibition
One Day, Something Happens:
Paintings of People
A Selection by Jennifer Higgie
from the Arts Council Collection

LEEDS ART GALLERY
6 March–24 May 2015

NOTTINGHAM CASTLE
20 June–6 September 2015

HIGHLANES GALLERY, DROGHEDA
17 October 2015–7 February 2016

THE ATKINSON, SOUTHPORT
20 February–22 May 2016

TOWNER, EASTBOURNE
15 October 2016–8 January 2017

Exhibition curated by Jennifer Higgie
Exhibition organised by Ann Jones
Assisted by Catherine Antoni and Steven Burridge

This exhibition has been made possible by the provision
of insurance through the Government Indemnity Scheme.
Hayward Gallery would like to thank HM Government for
providing Government Indemnity and the Department
of Culture, Media and Sport and Arts Council England for
arranging the indemnity.

Published by Hayward Publishing
Southbank Centre
Belvedere Road
London
SE1 8XX, UK
www.southbankcentre.co.uk

Art Publisher: Ben Fergusson
Staff Editor: Catherine Gaffney
Sales Officer: Alex Glen
Press and Marketing Coordinator:
Diana Adell
Catalogue designed by Melanie Mues
Printed in China by Everbest Co.Ltd.

© Southbank Centre 2014
Texts © the authors 2014
Artworks © the artist 2014
(unless otherwise stated)

ISBN 978 1 85332 330 0

All rights reserved. No part of this publication
may be reproduced, stored in a retrieval system
or transmitted in any form or by any means,
electrical, mechanical or otherwise, without first
seeking the written permission of the copyright
holders and of the publisher. The publisher
has made every effort to contact all copyright
holders. If proper acknowledgement has not
been made, we ask copyright holders to contact
the publisher. A catalogue record for this book
is available from the British Library.

This catalogue is not intended to be used
for authentication or related purposes.
The Southbank Board Limited accepts no
liability for any errors or omissions that
the catalogue may inadvertently contain.

Distributed in North America,
Central America and South
America by D.A.P. / Distributed Art
Publishers, Inc.,
155 Sixth Avenue, 2nd Floor,
New York, NY 10013
T +212 627 1999
F +212 627 9484
www.artbook.com

Distributed in the UK
and Europe,
by Cornerhouse Publications
70 Oxford Street,
Manchester M1 5NH
T +44 (0)161 200 1503
F +44 (0)161 200 1504
www.cornerhouse.org/books

Cover image: Lynette Yiadom-Boakye,
Condor and the Mole, 2011 (detail)

Sickert's 'One day, something happens...'
quote is taken from a letter held by the
Tate and is quoted in Matthew Sturgis,
Walter Sickert: *A Life*, (London: Harper
Perennial, 2005), p. 445